HOW TO DRAW ROBLOX PIG

The Step By Step Guide To Drawing 10 Cute Roblox Piggy Characters Easily (Book 1).

KATHY YOUNG

ISBN: 9798553653620

Table of Contents

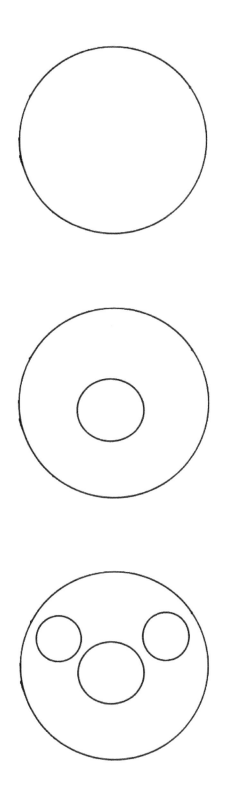

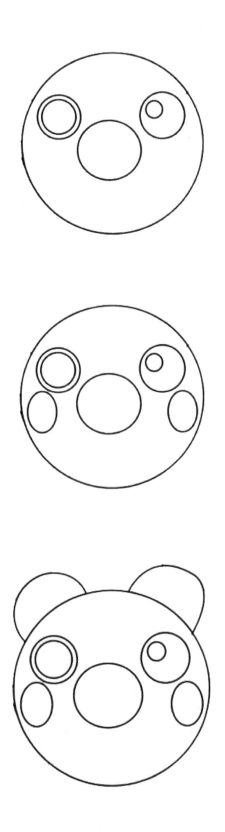

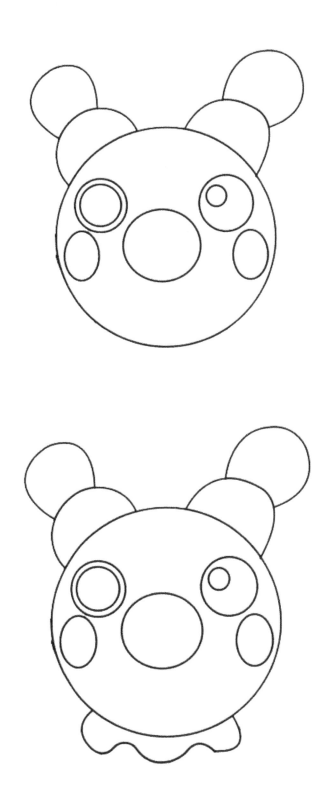

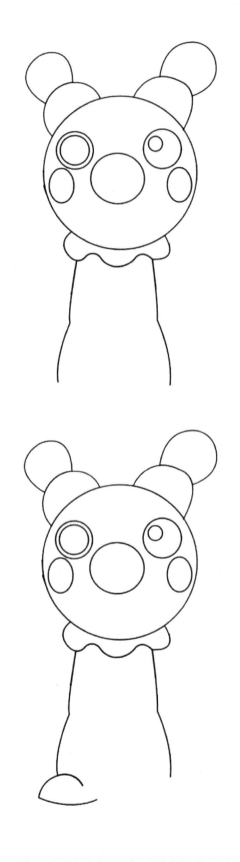

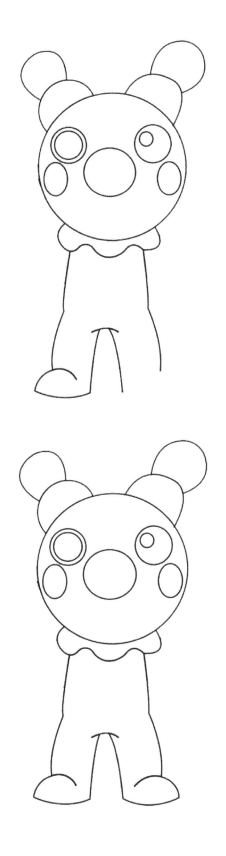

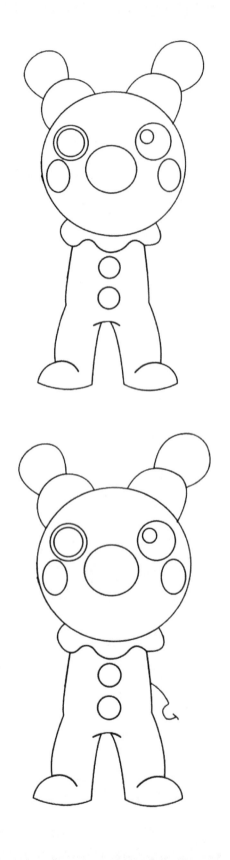

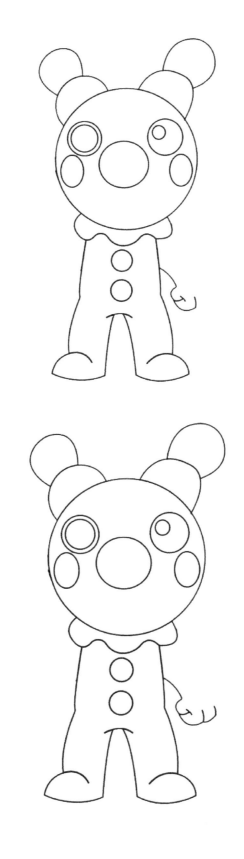

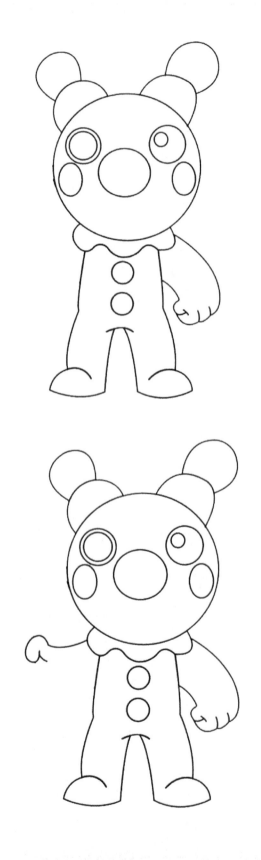

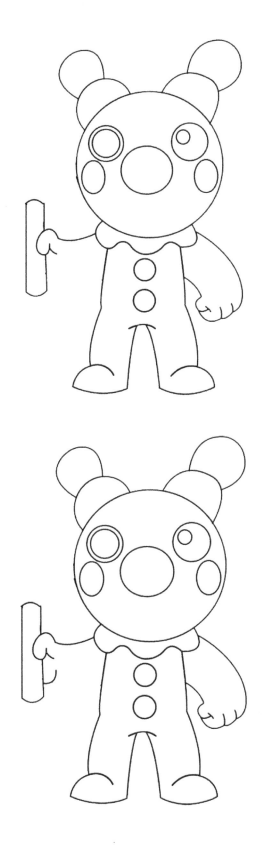

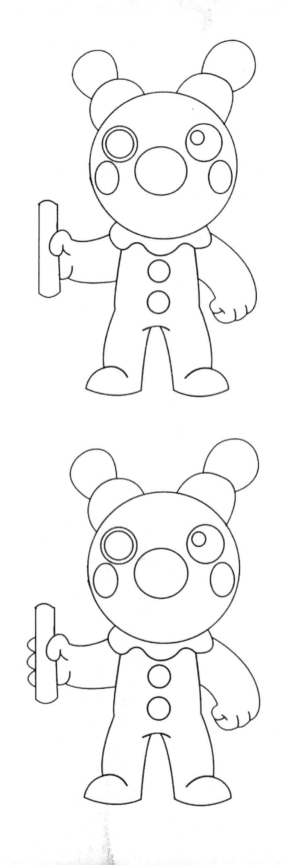

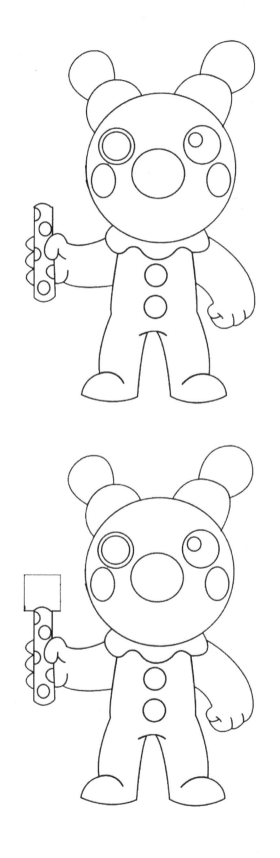

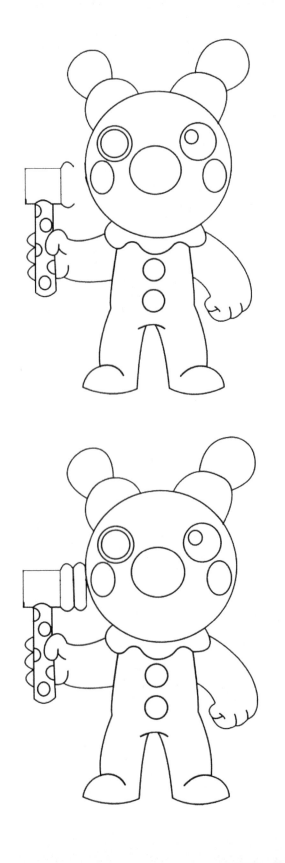

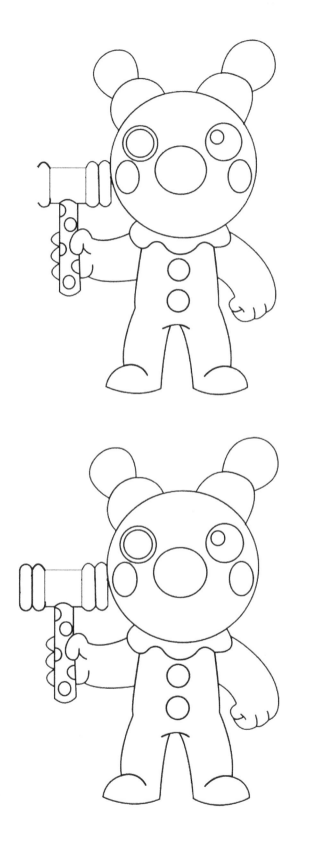

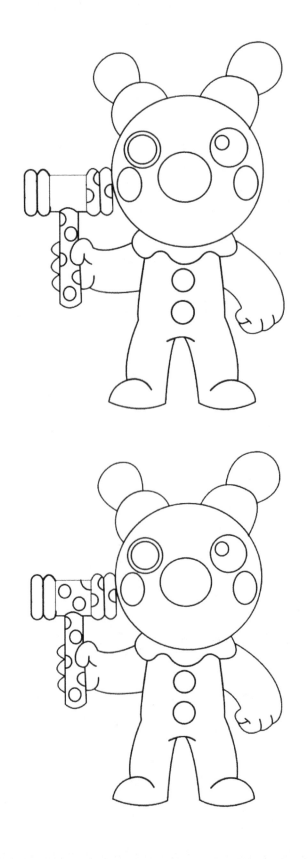

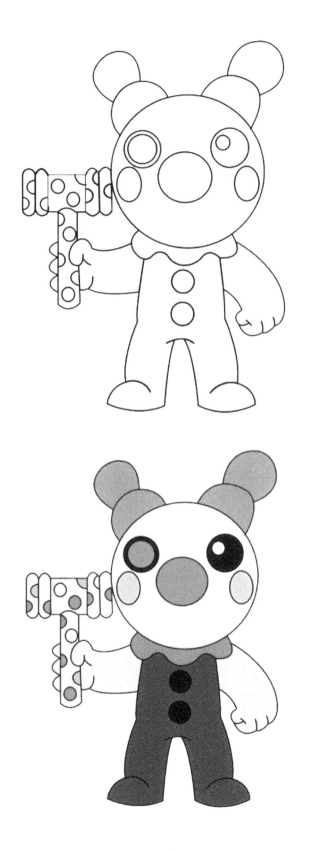

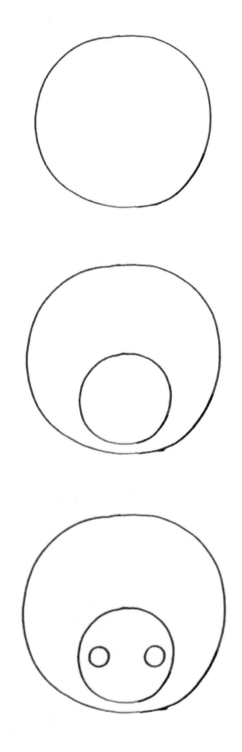

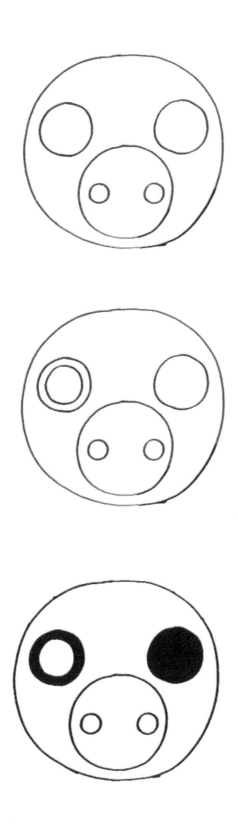

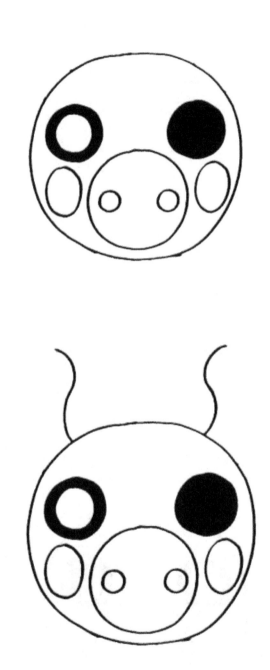

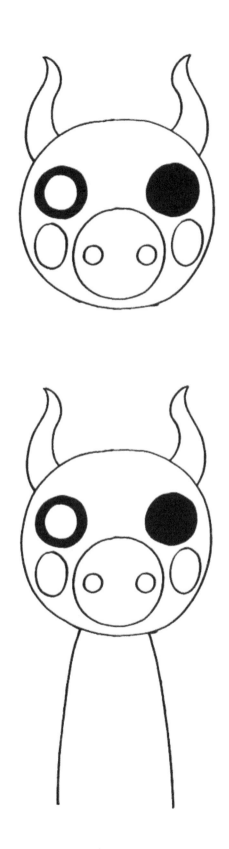

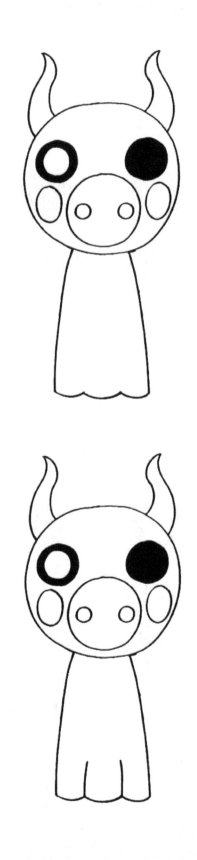

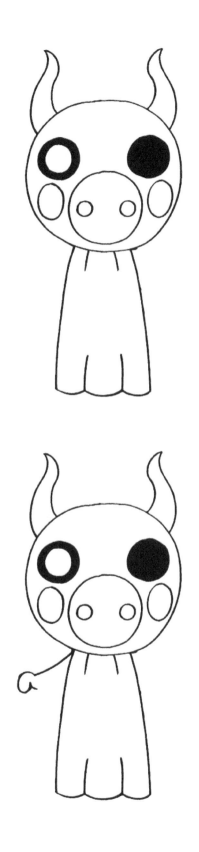

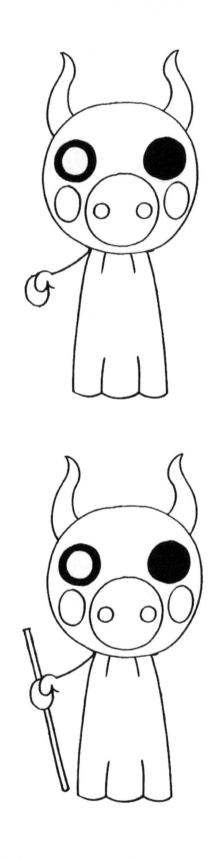

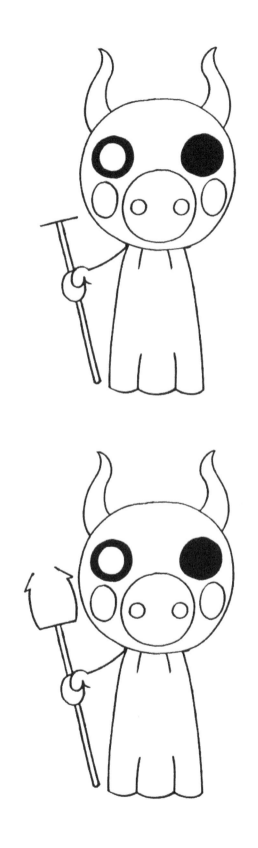

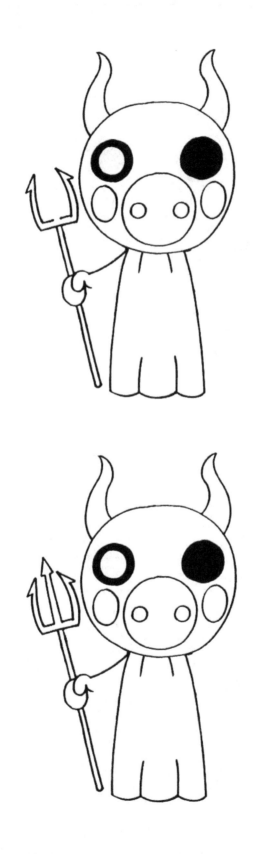

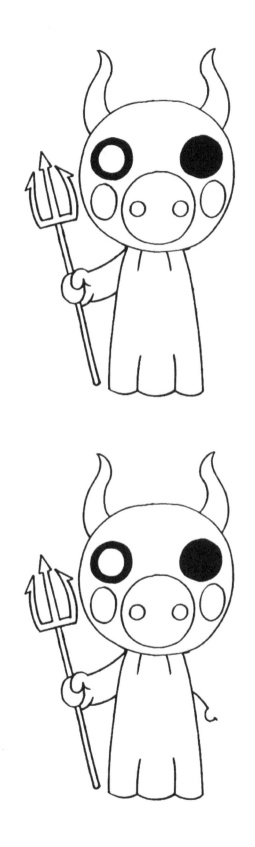

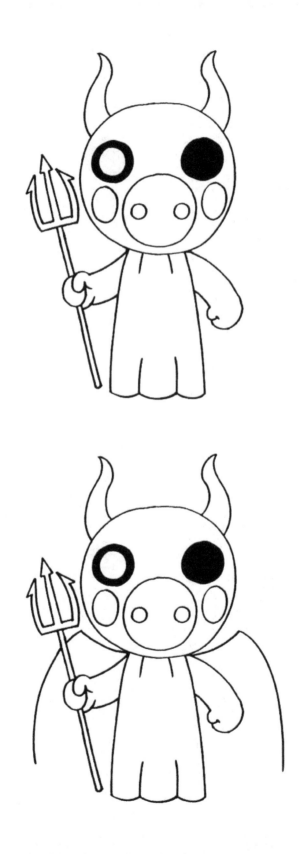

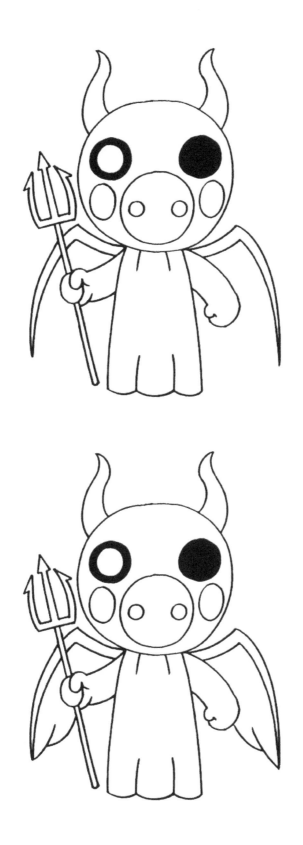

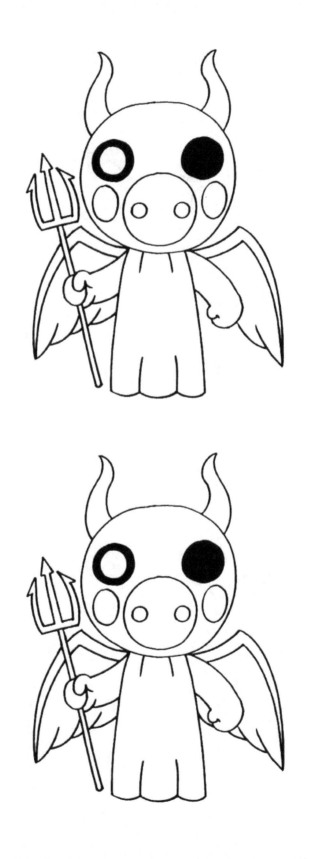

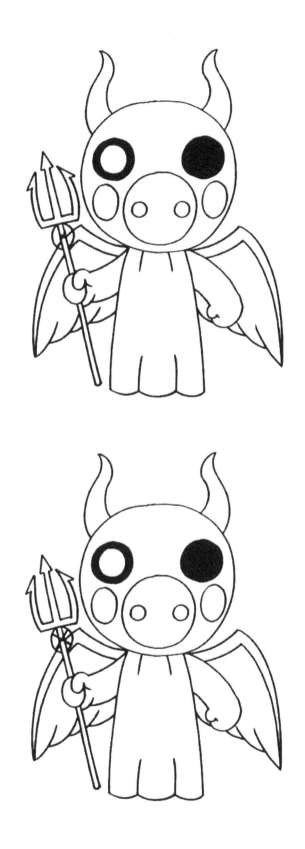

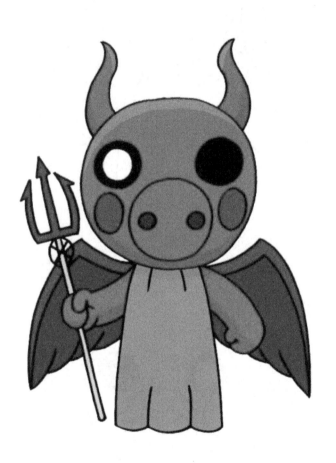

CHAPTER 3: HOW TO DRAW DINO STEP BY STEP

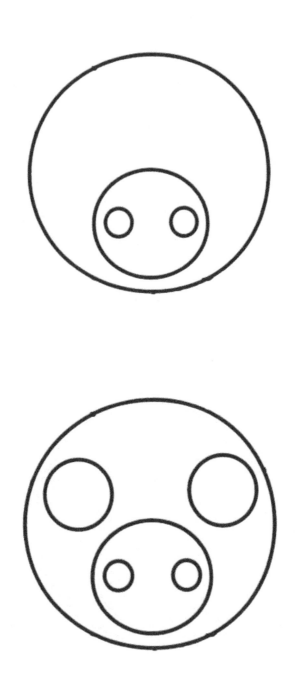

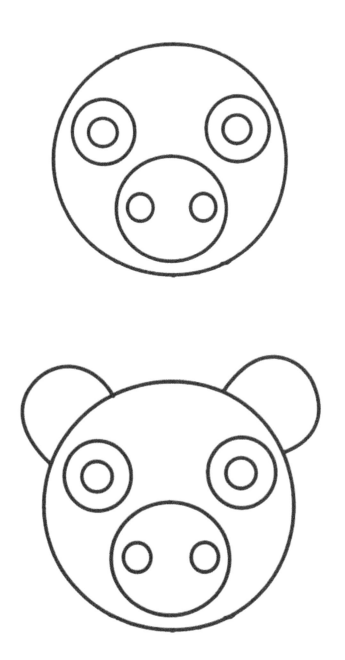

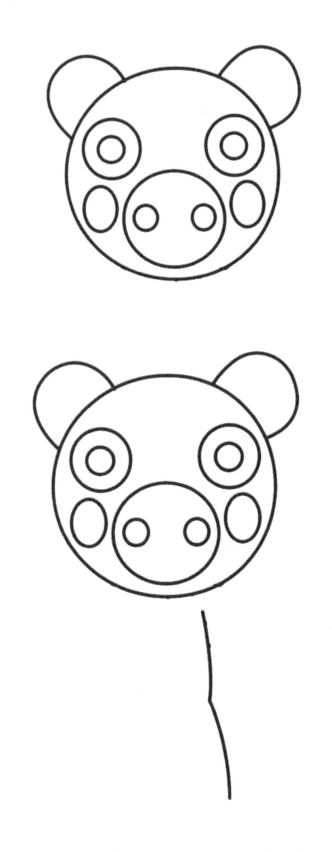

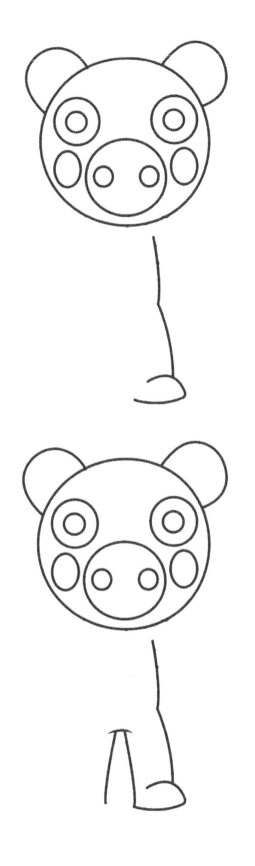

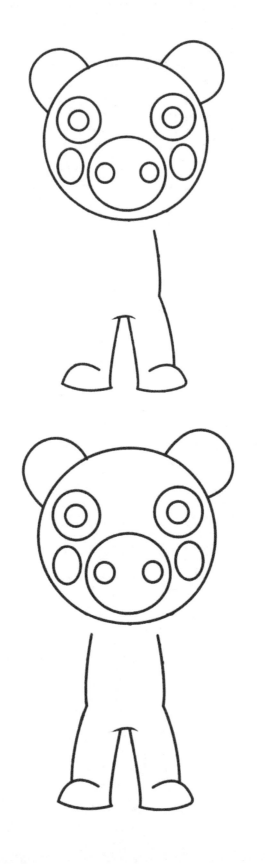

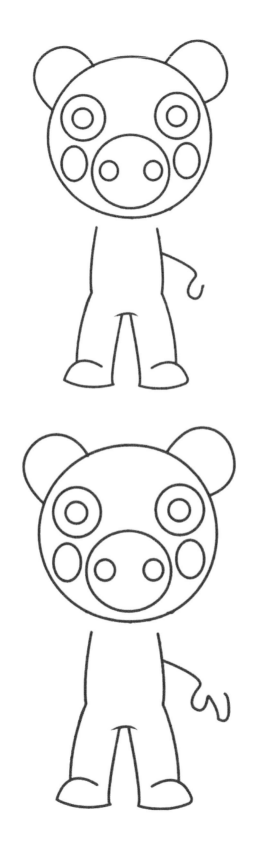

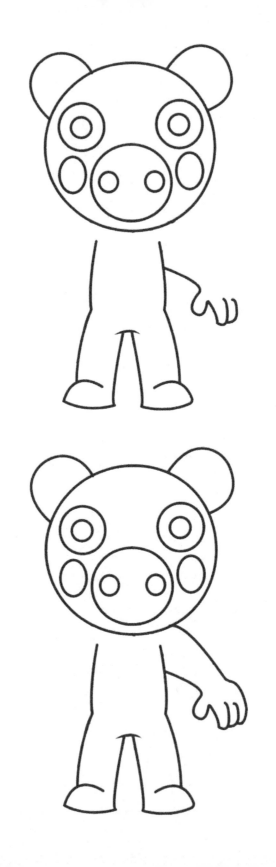

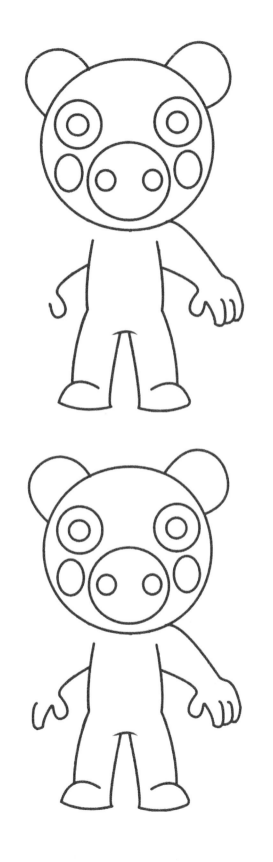

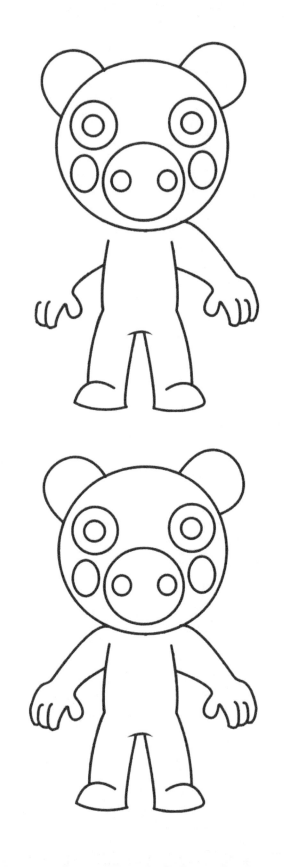

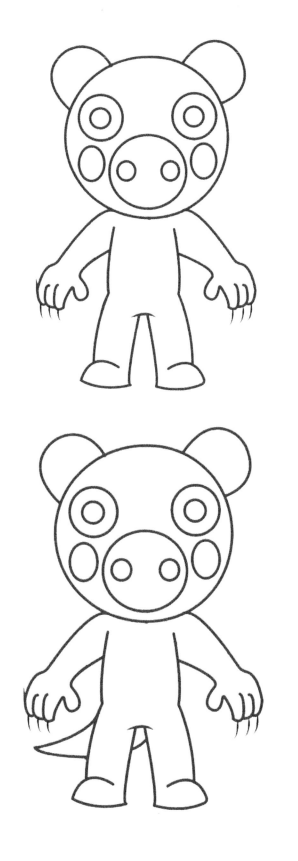

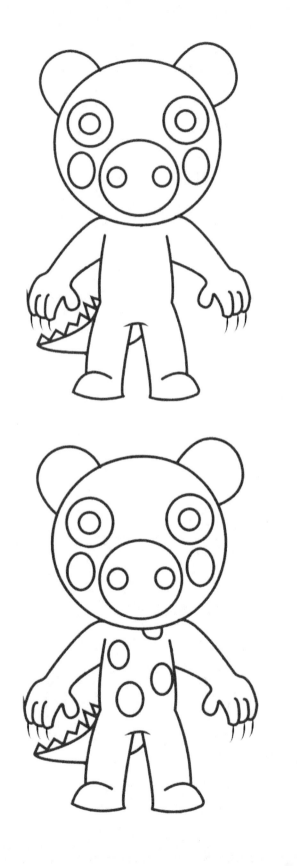

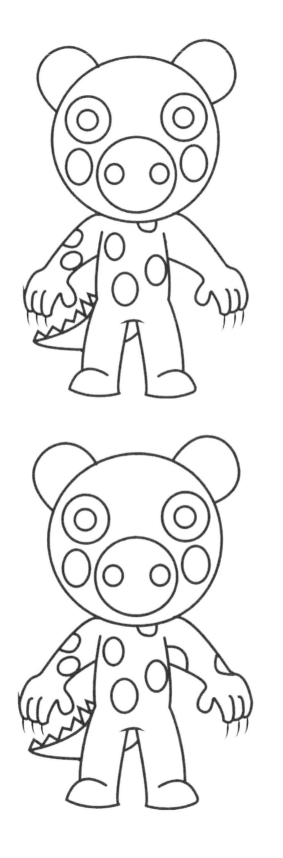

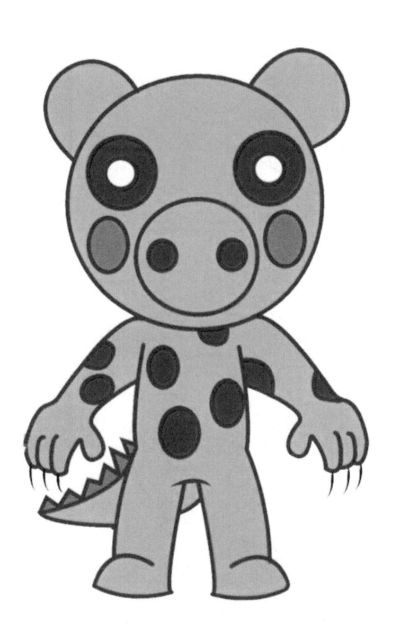

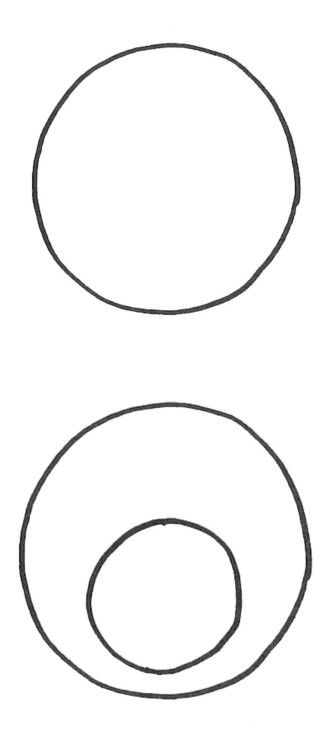

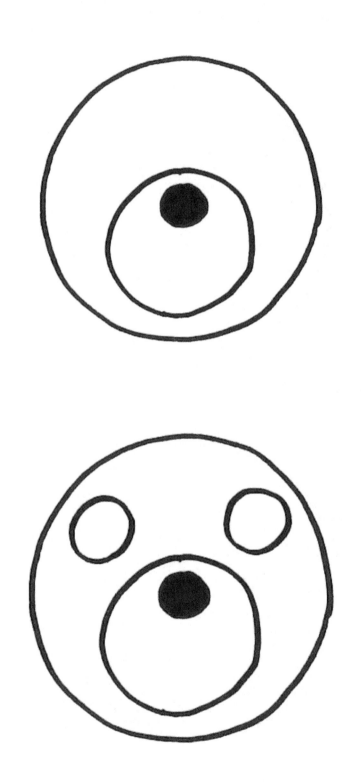

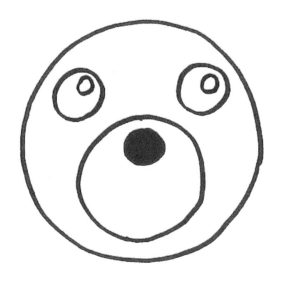

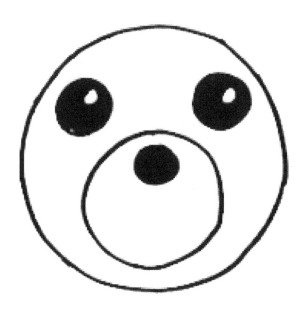

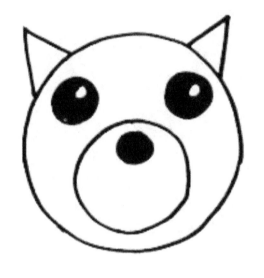

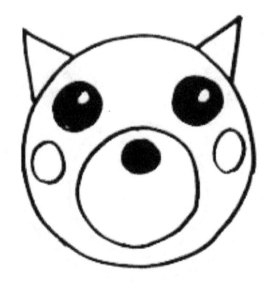

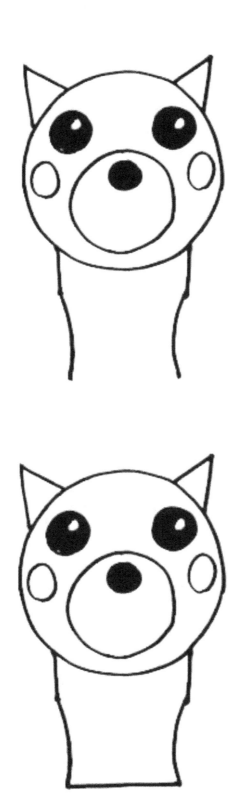

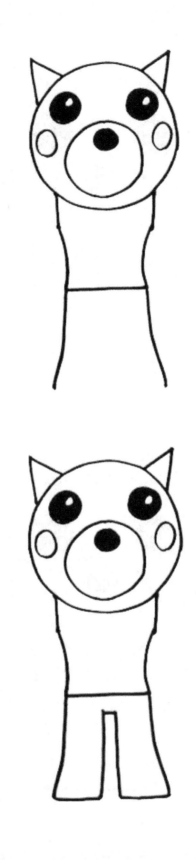

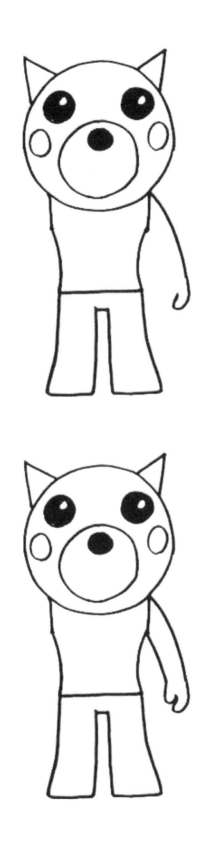

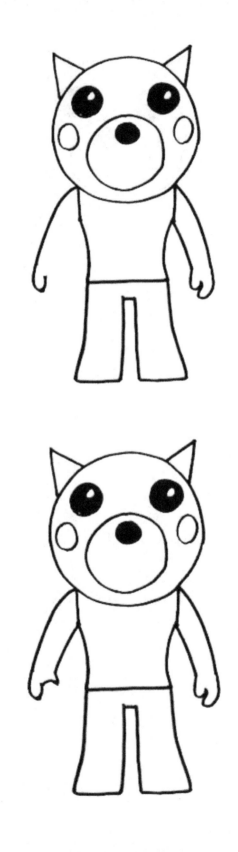

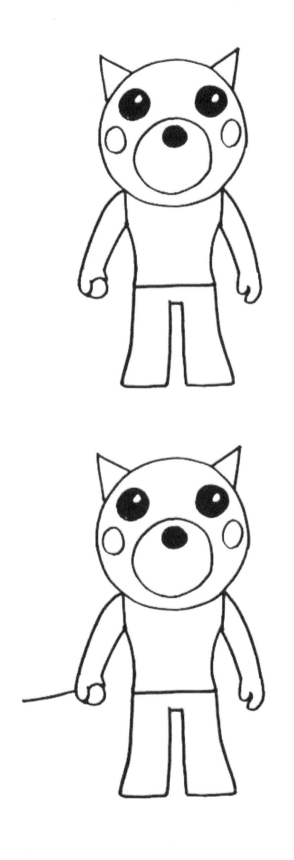

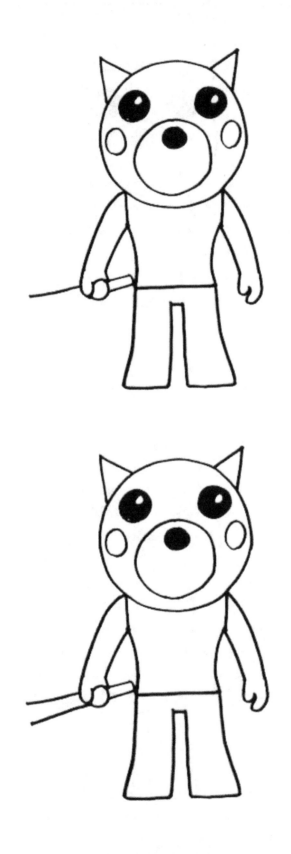

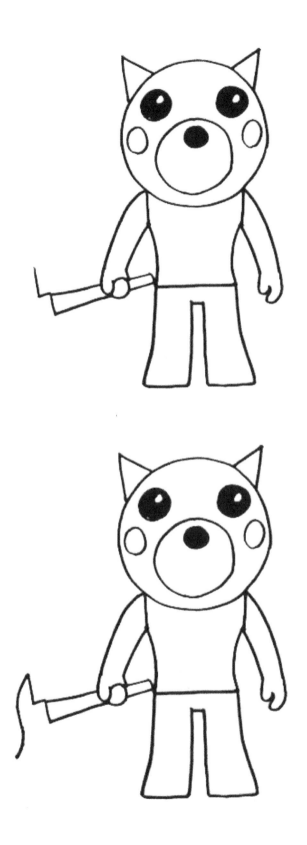

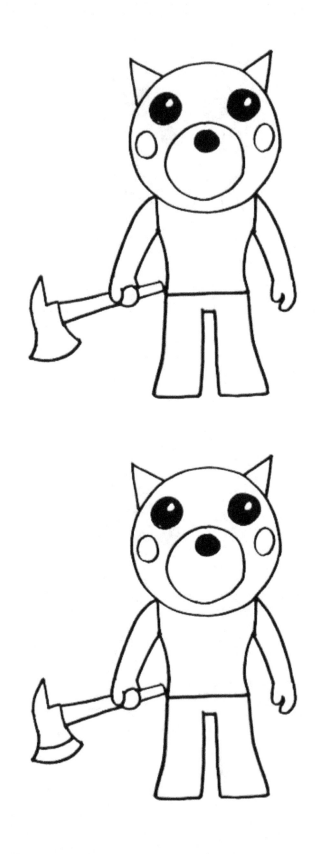

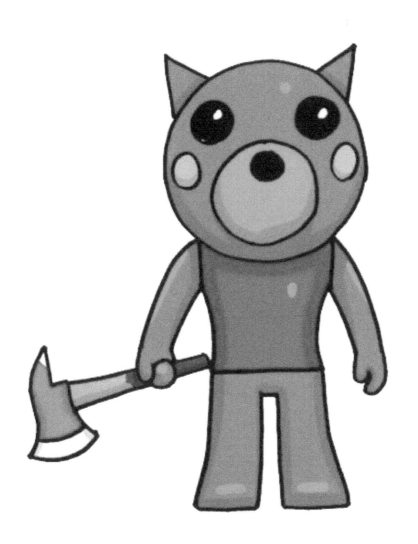

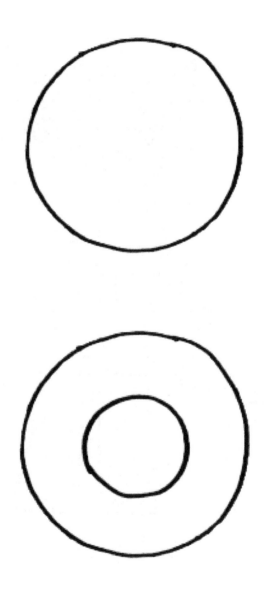

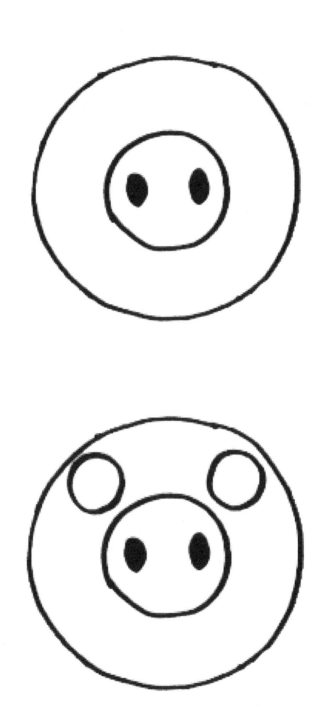

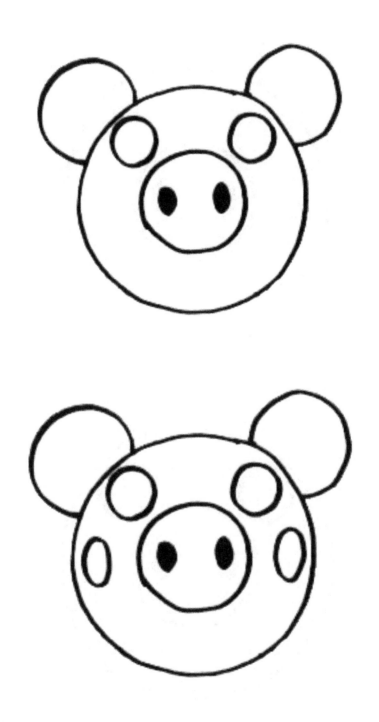

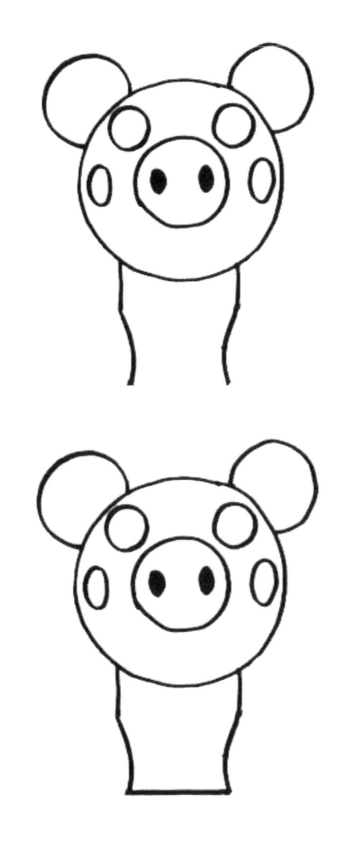

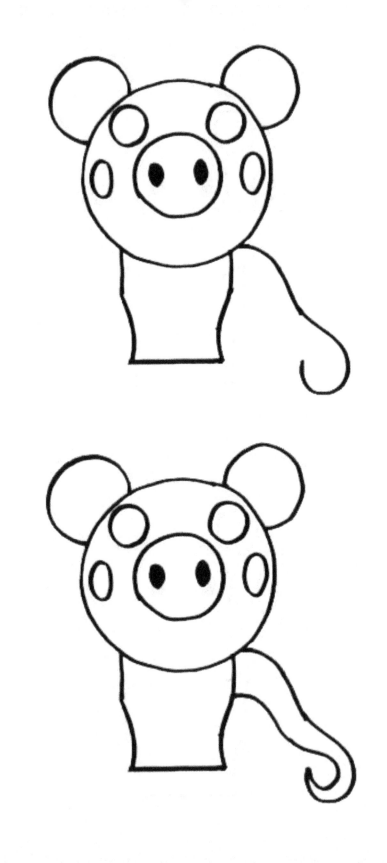

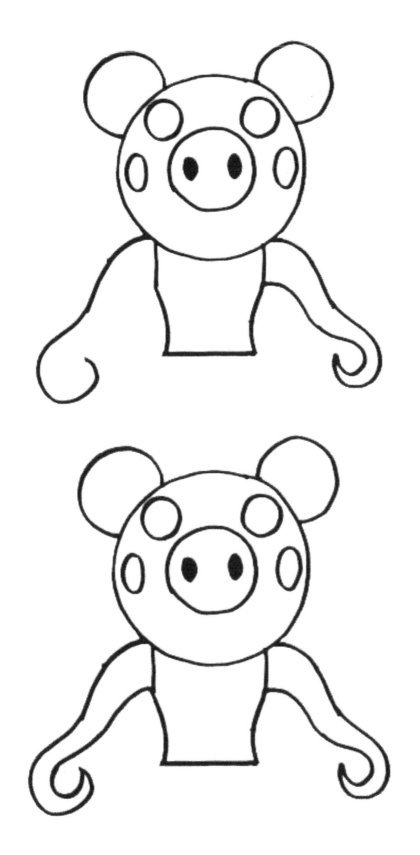

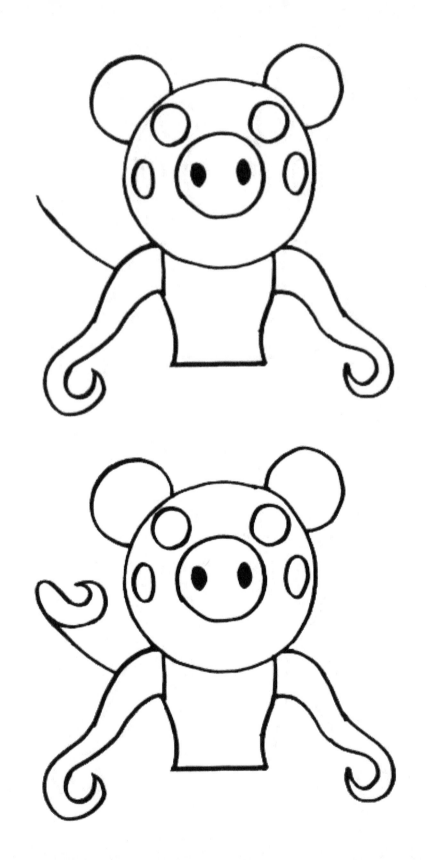

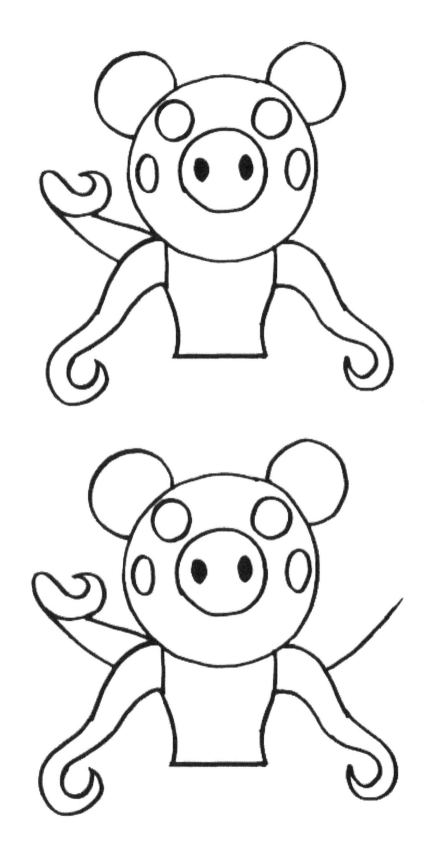

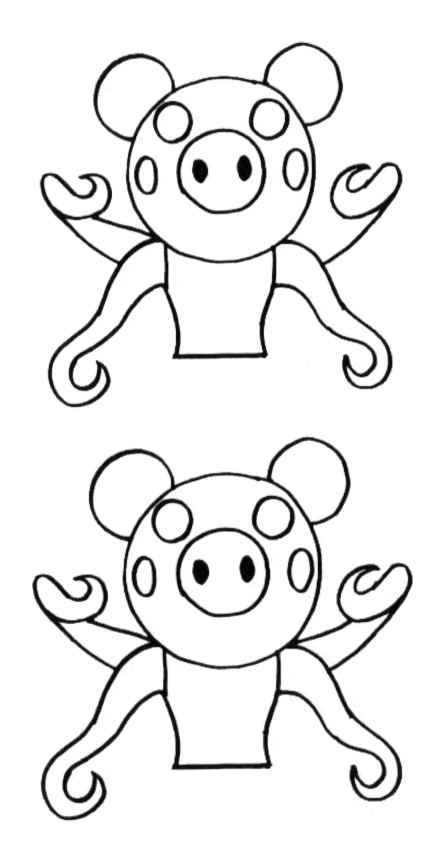

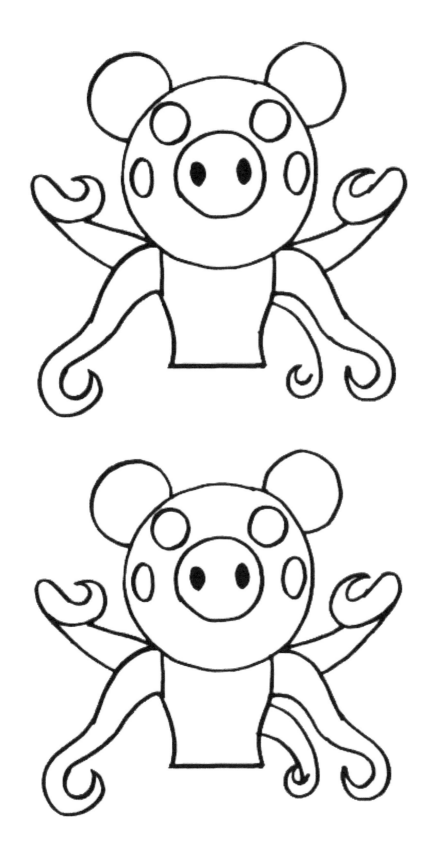

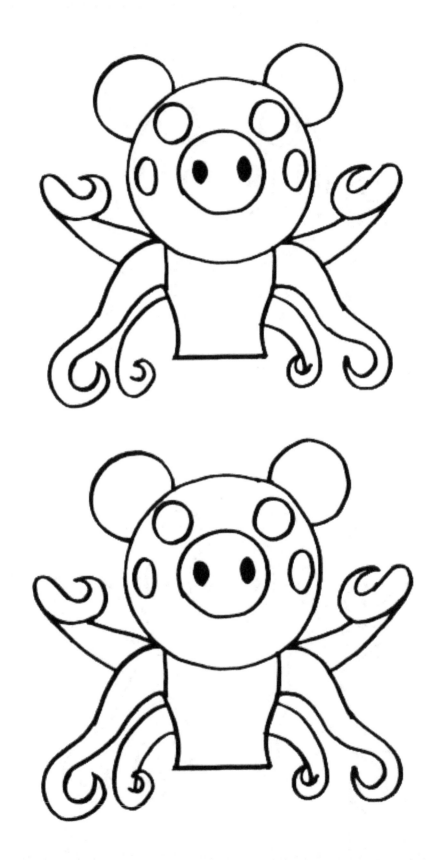

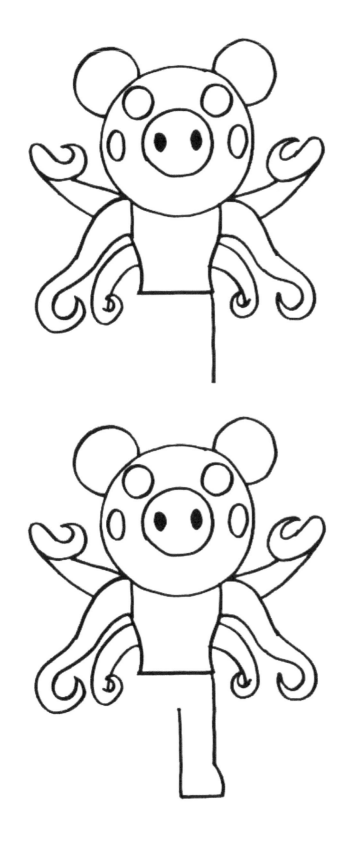

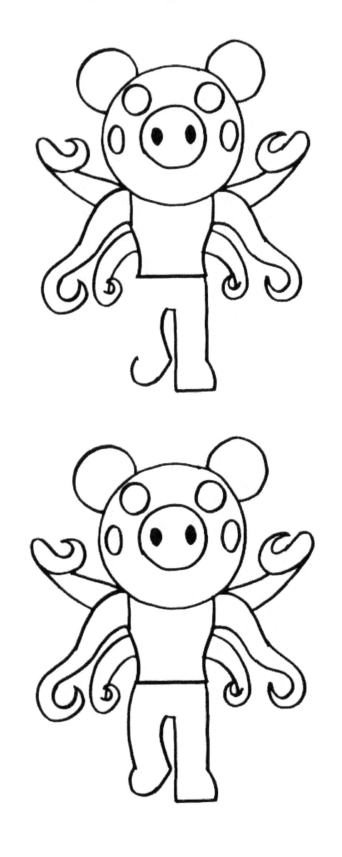

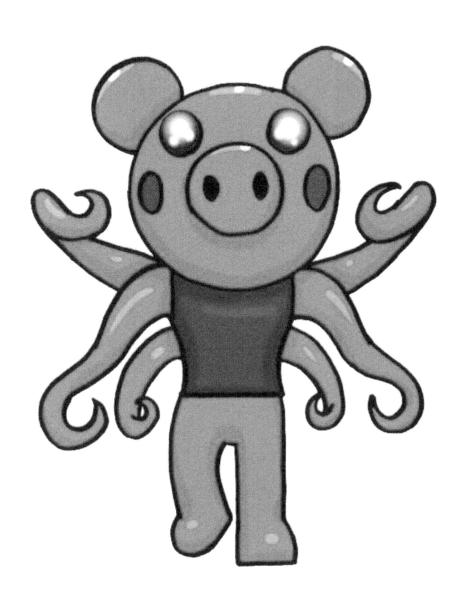

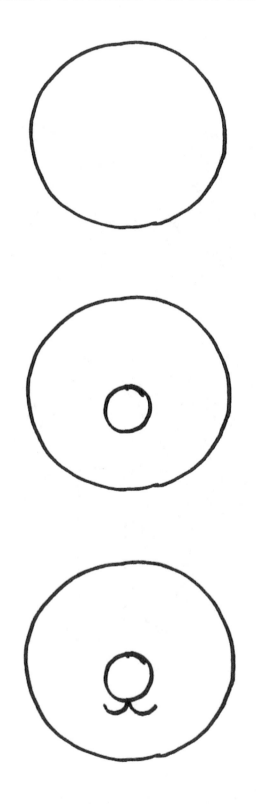

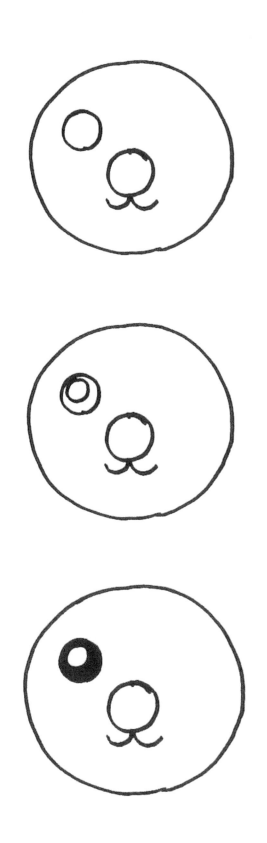

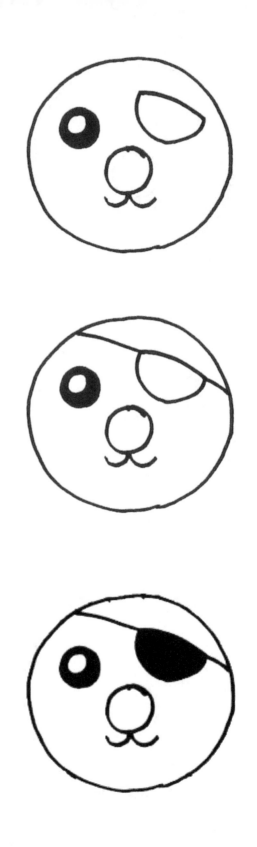

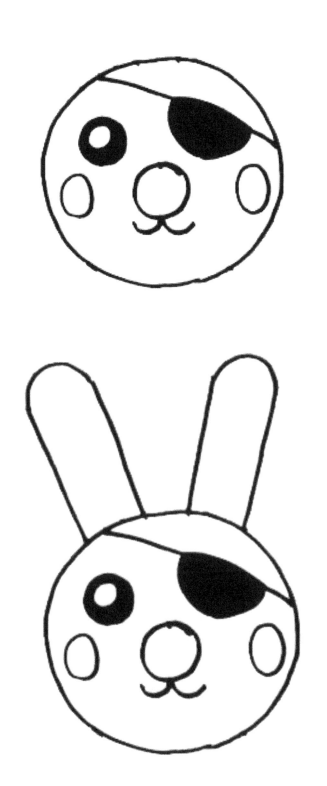

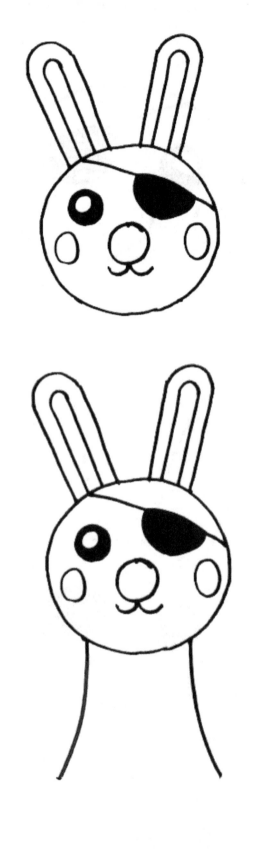

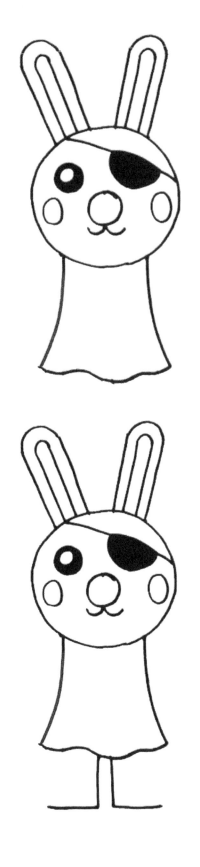

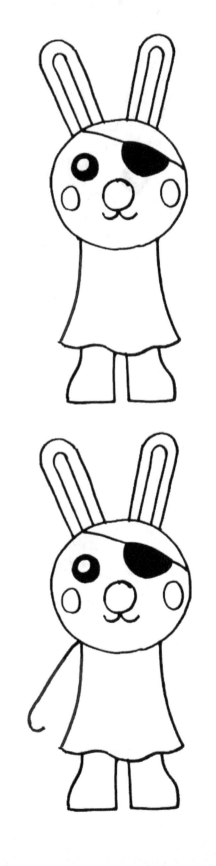

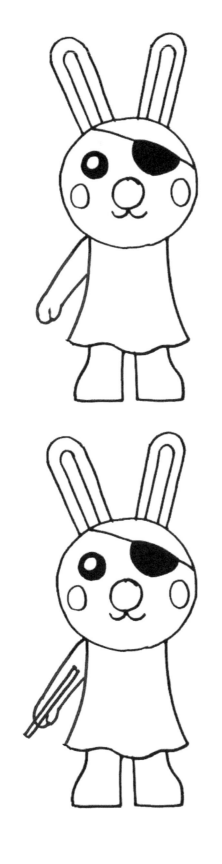

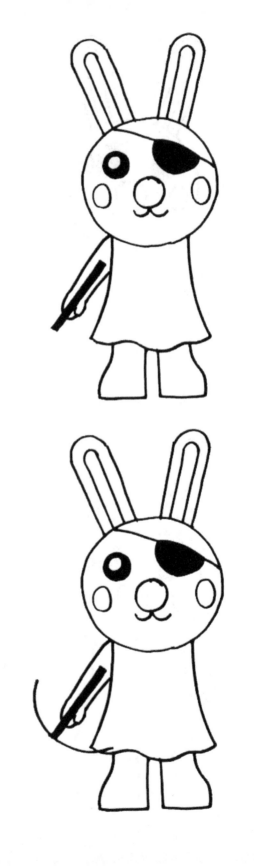

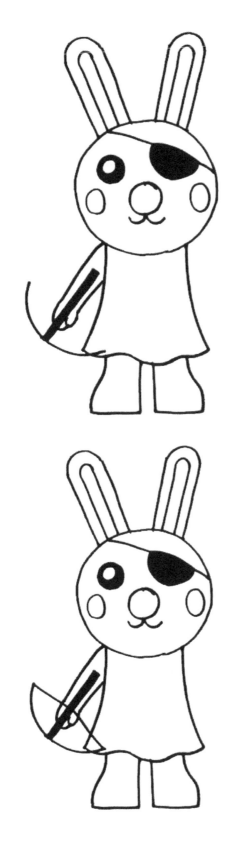

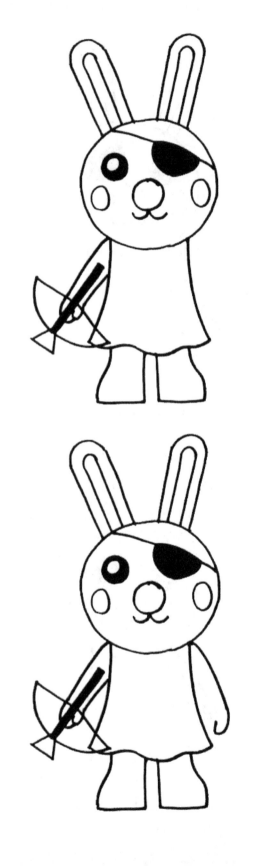

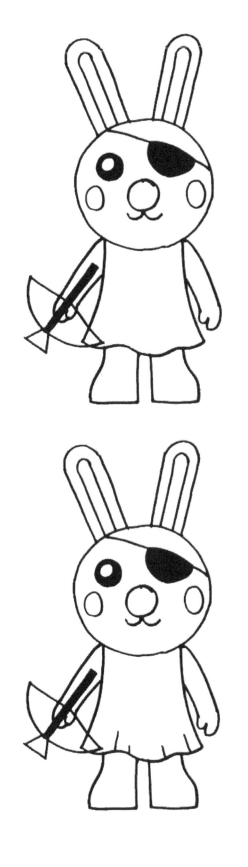

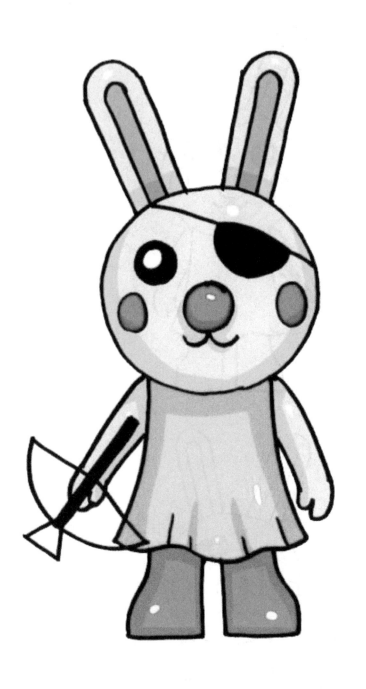

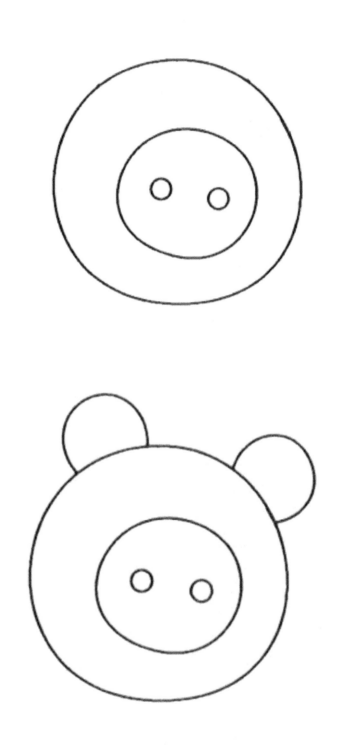

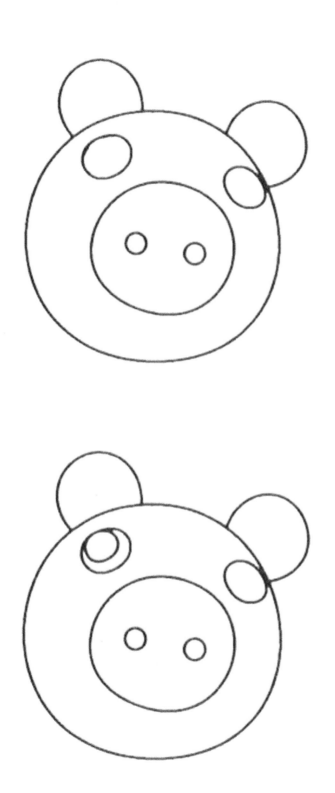

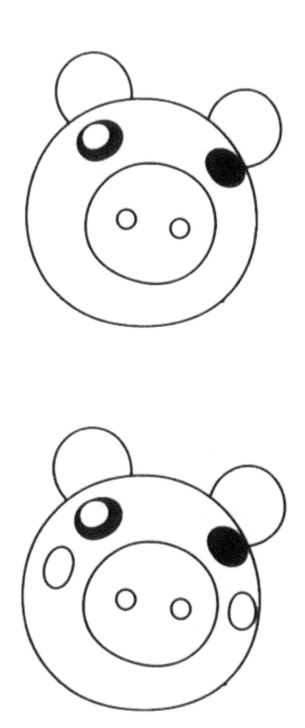

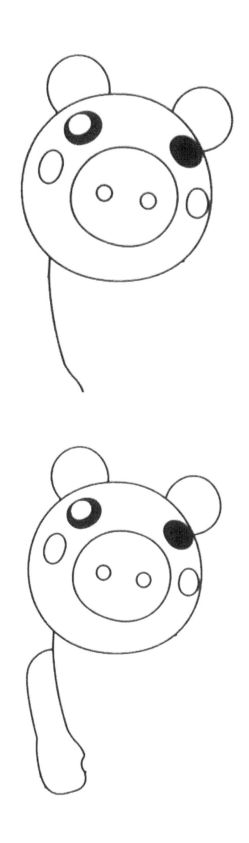

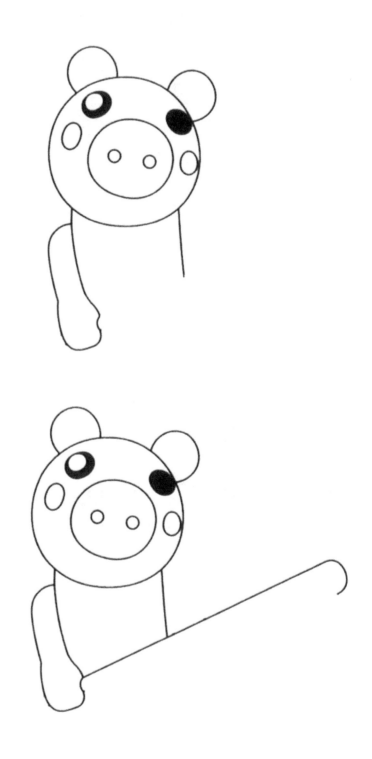

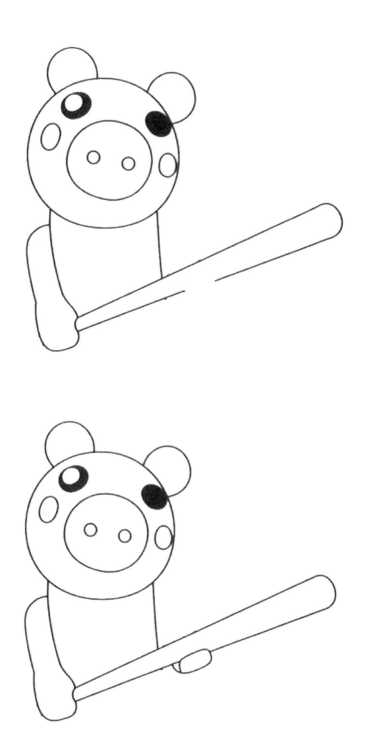

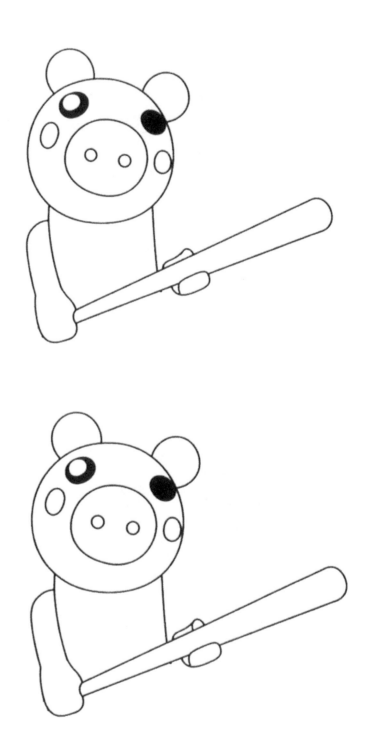

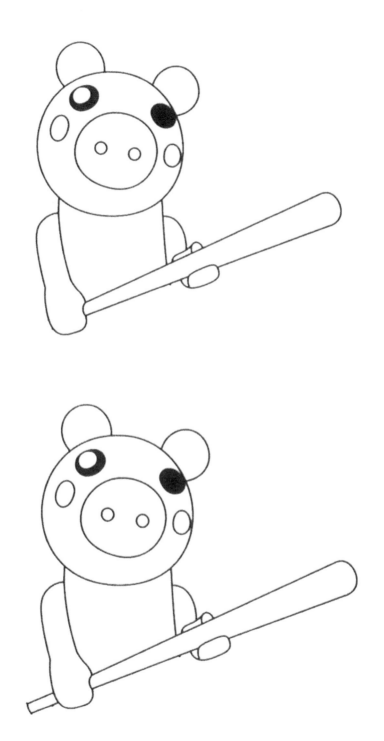

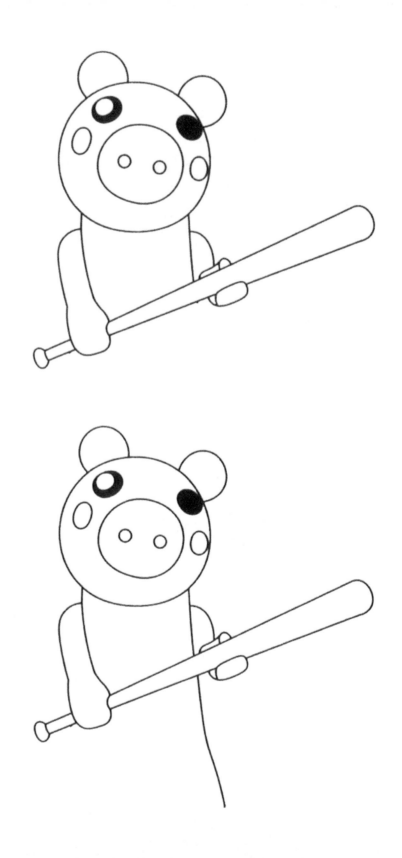

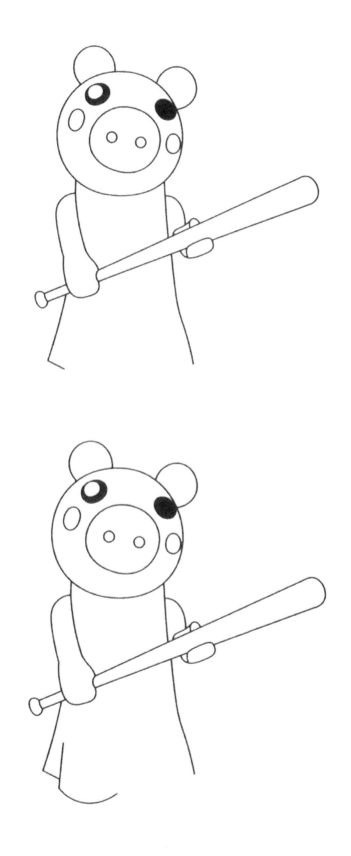

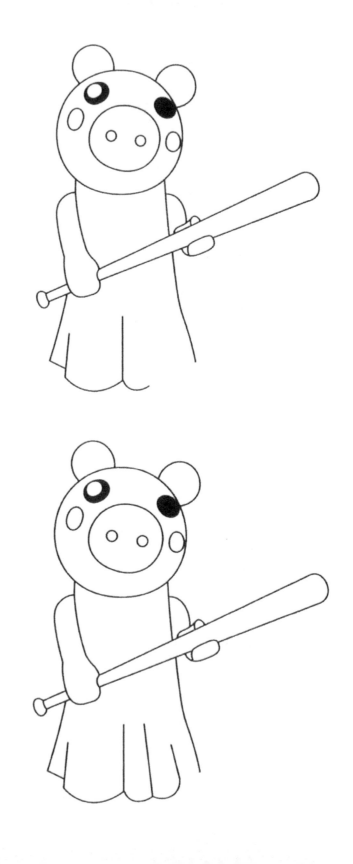

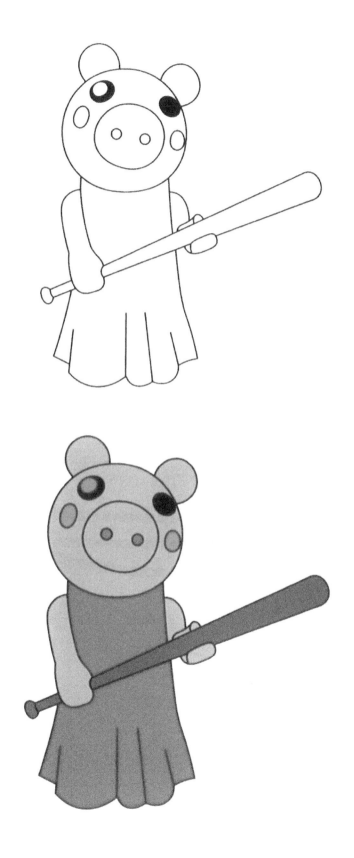

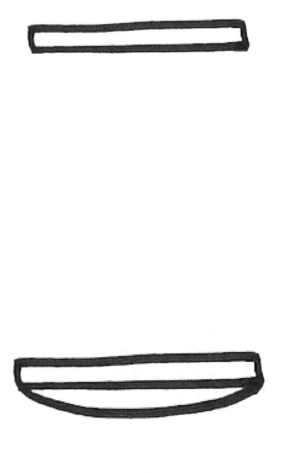

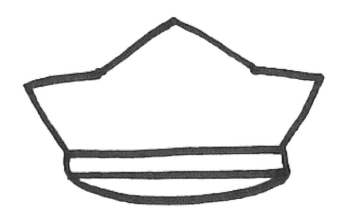

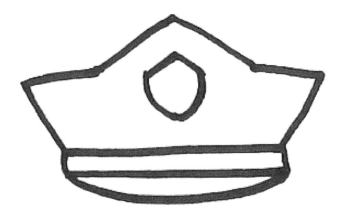

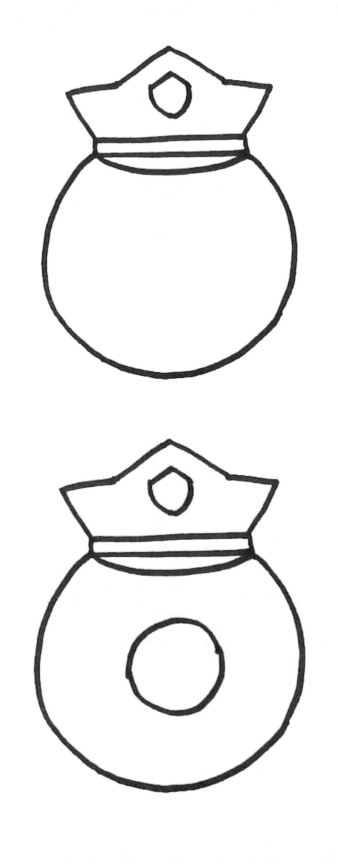

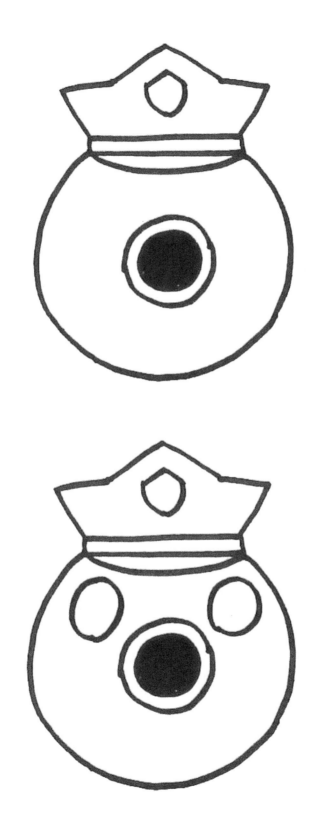

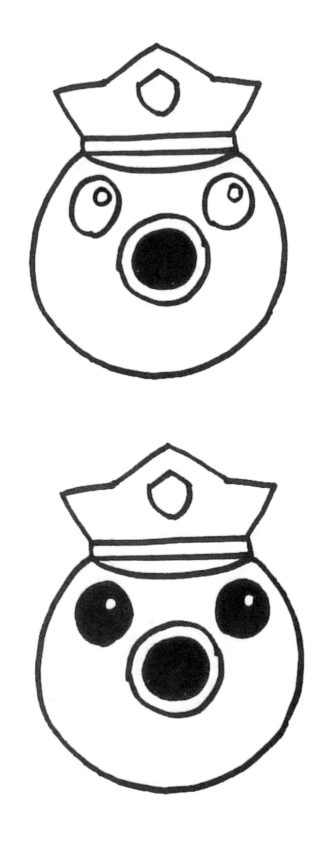

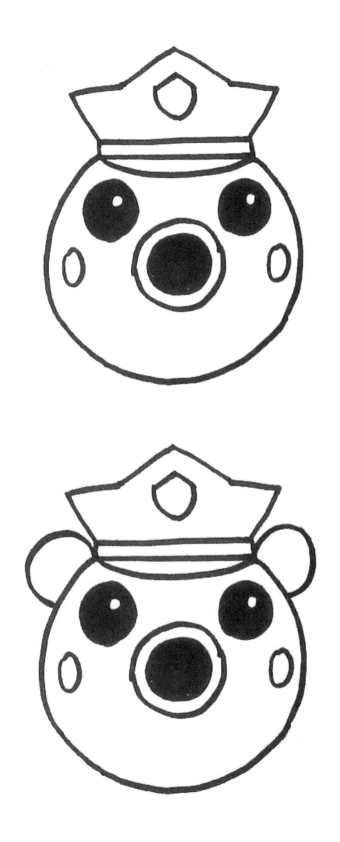

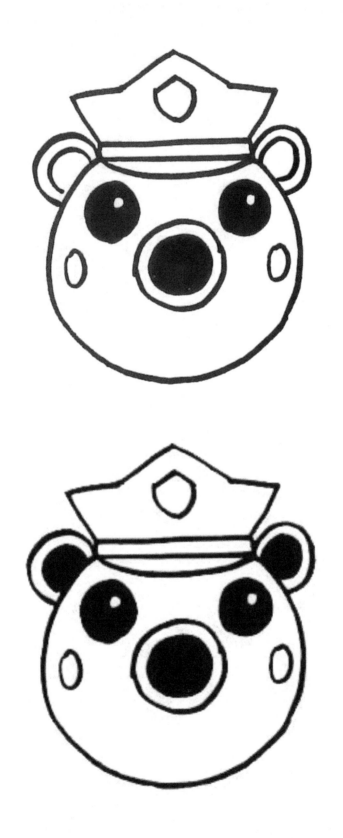

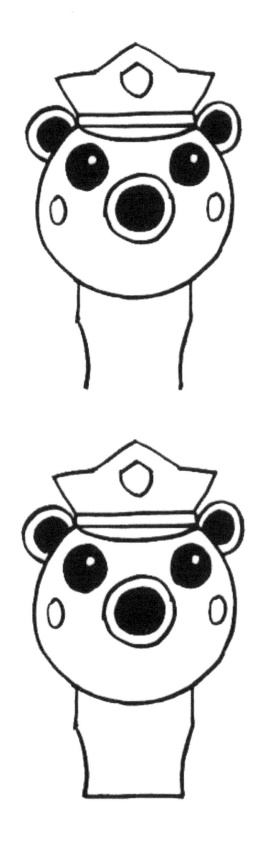

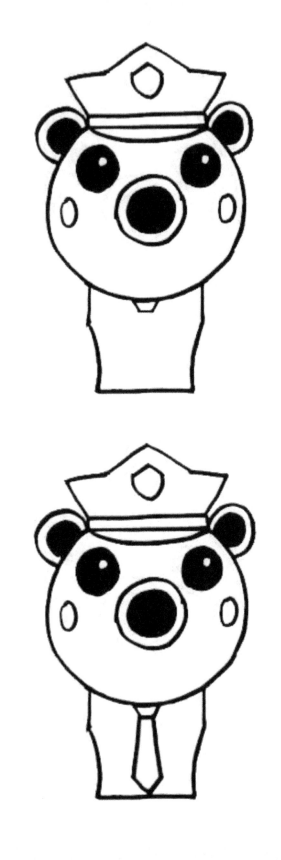

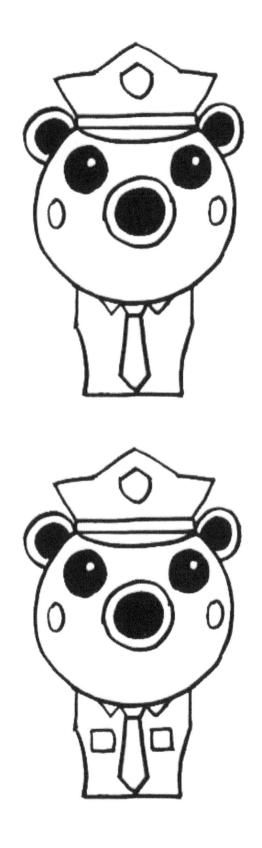

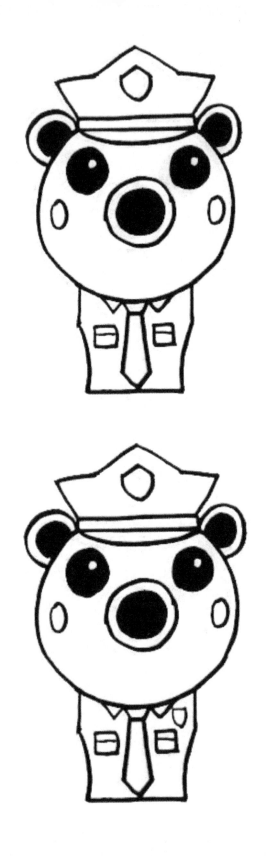

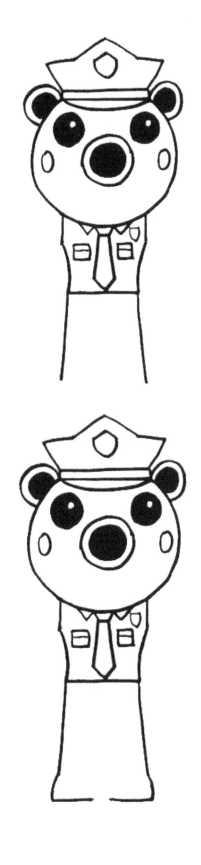

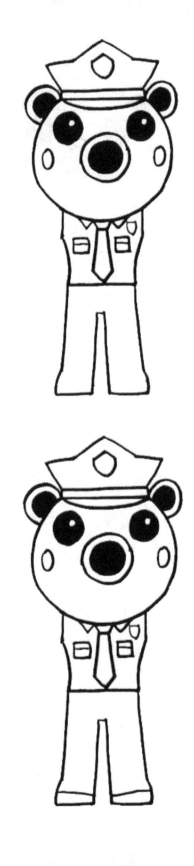

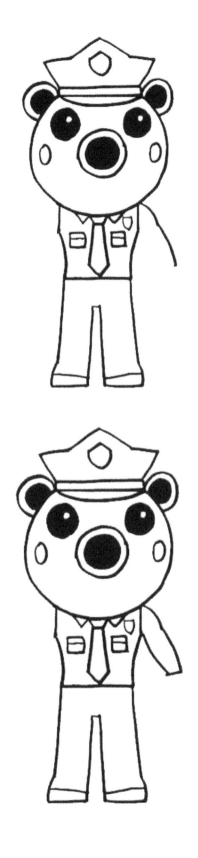

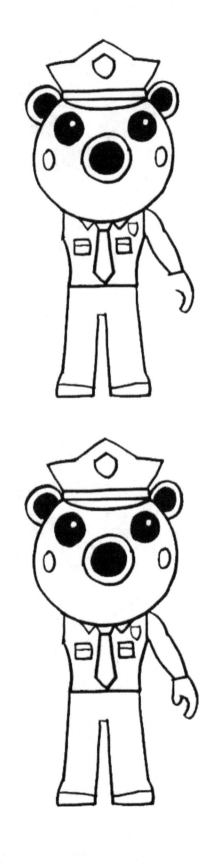

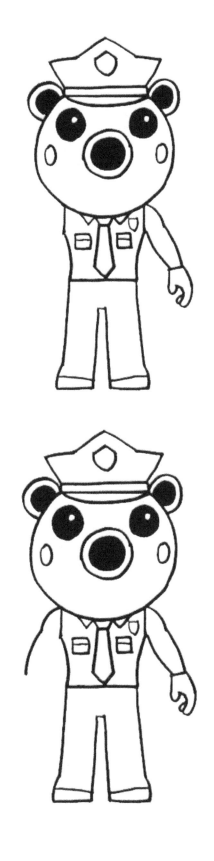

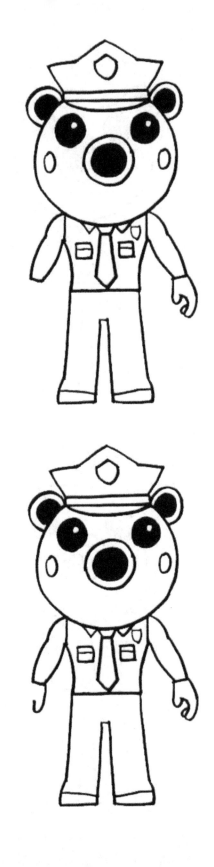

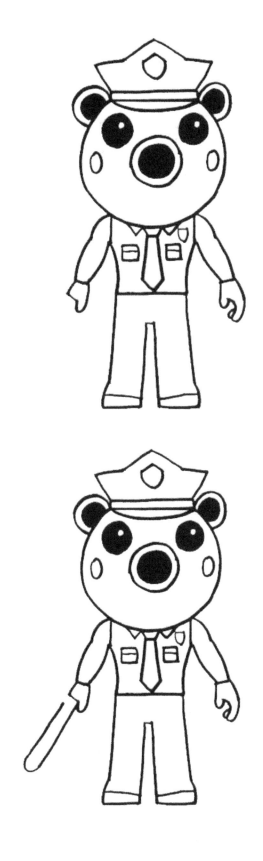

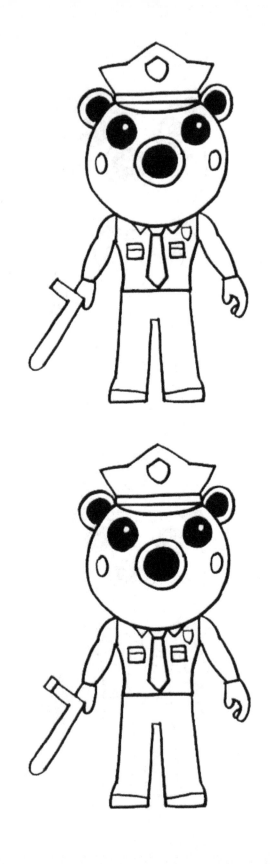

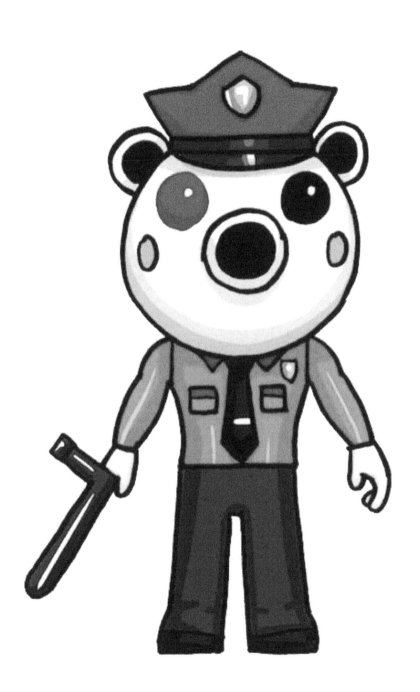

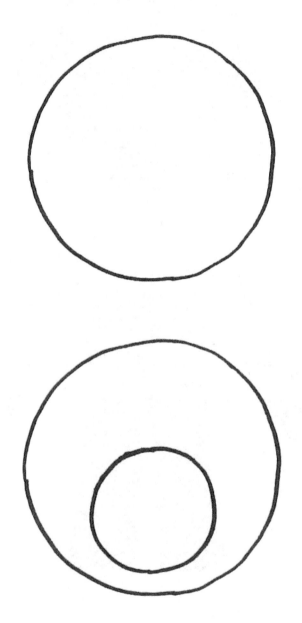

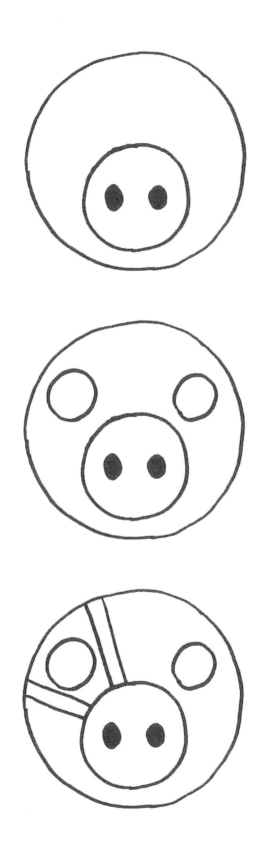

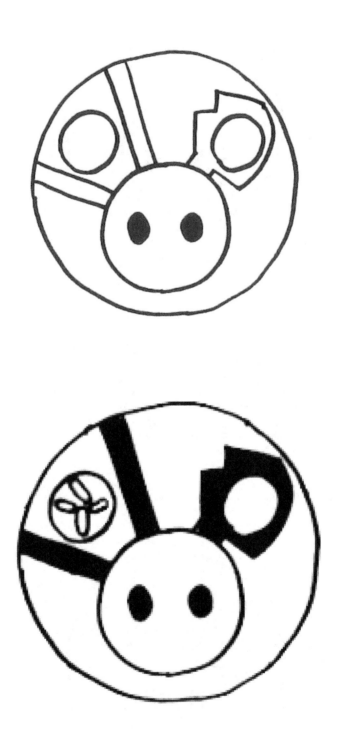

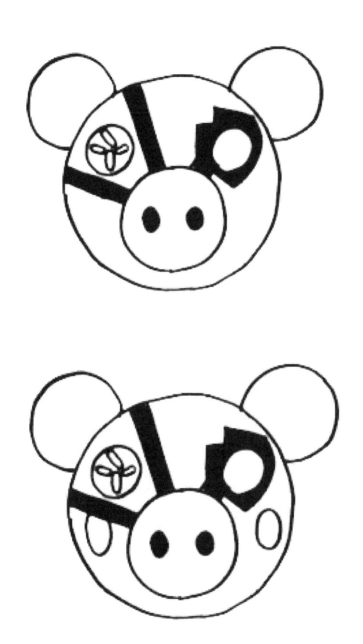

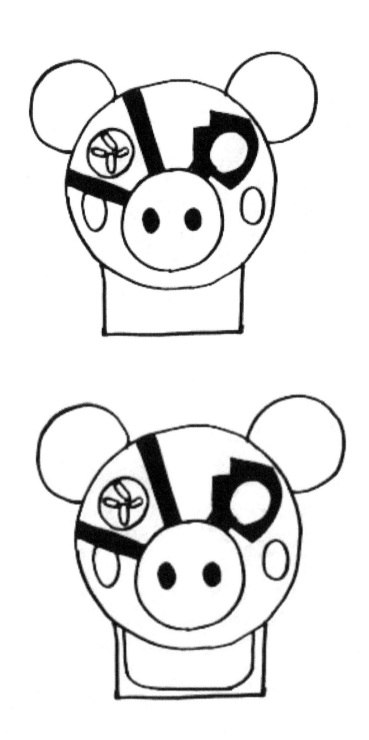

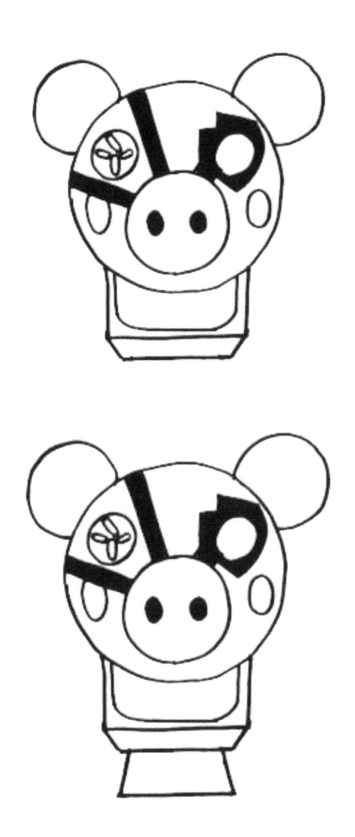

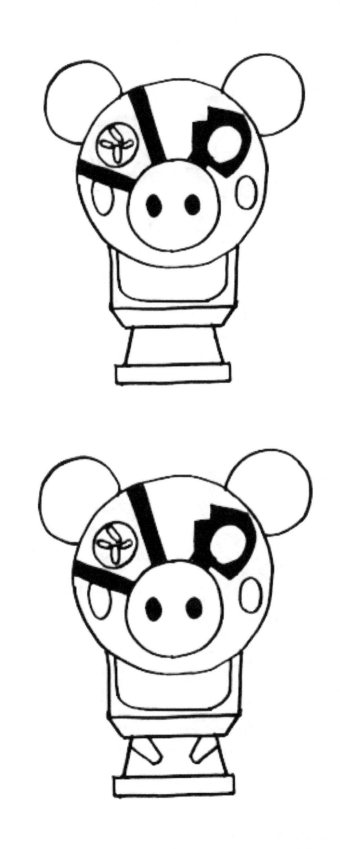

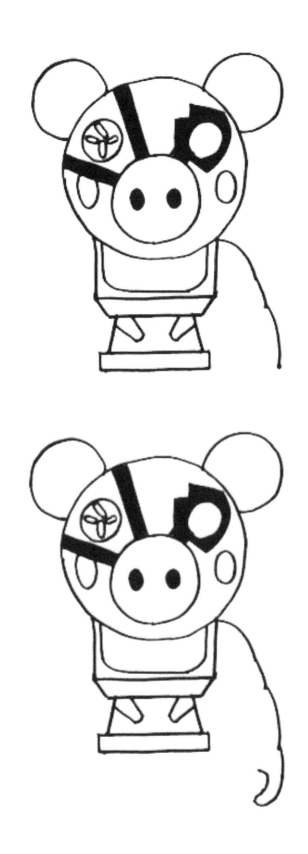

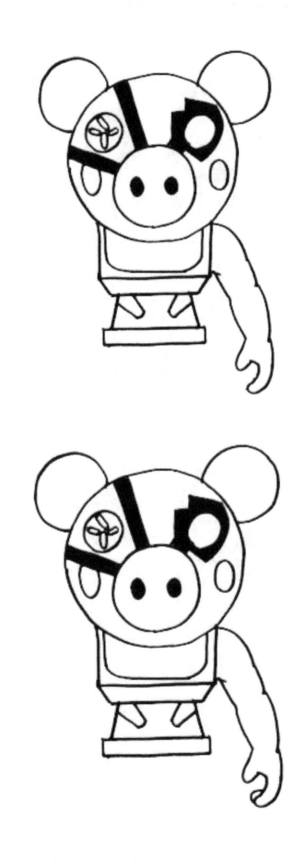

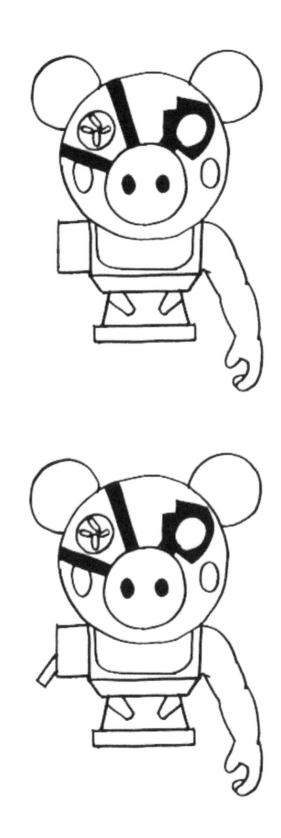

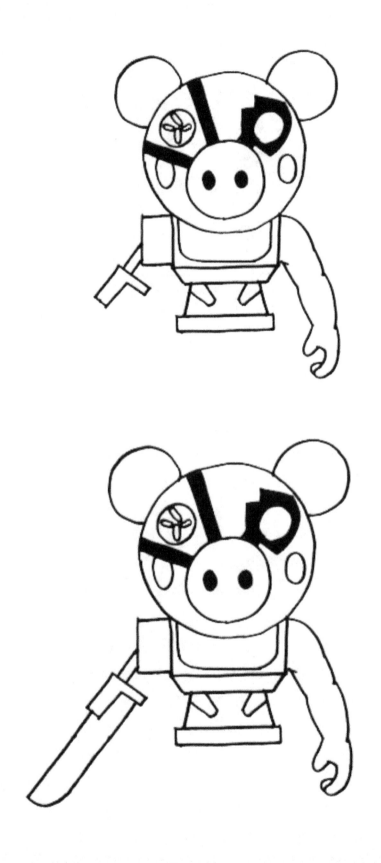

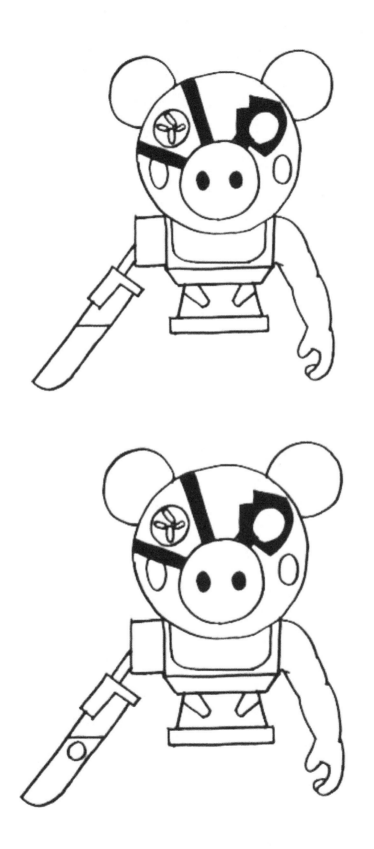

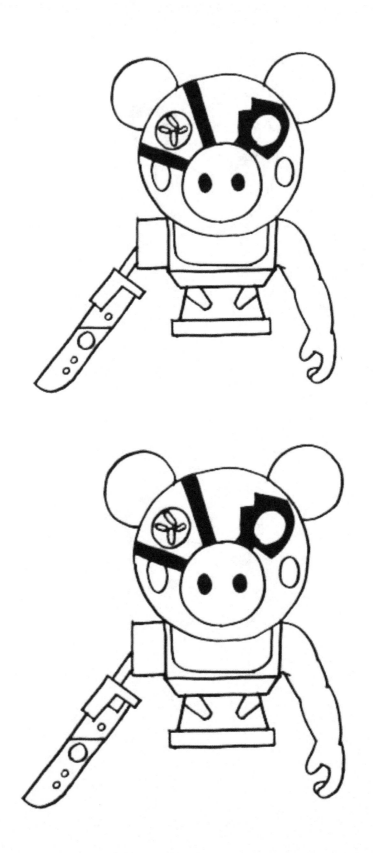

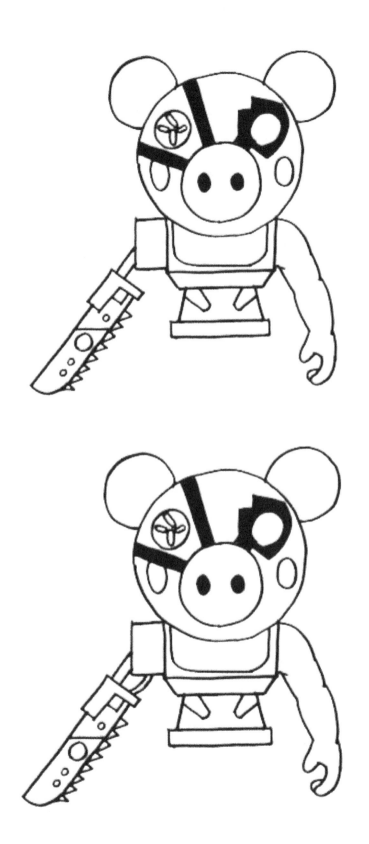

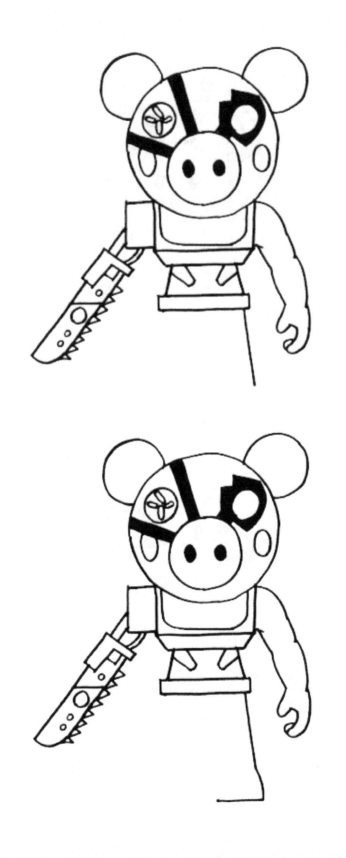

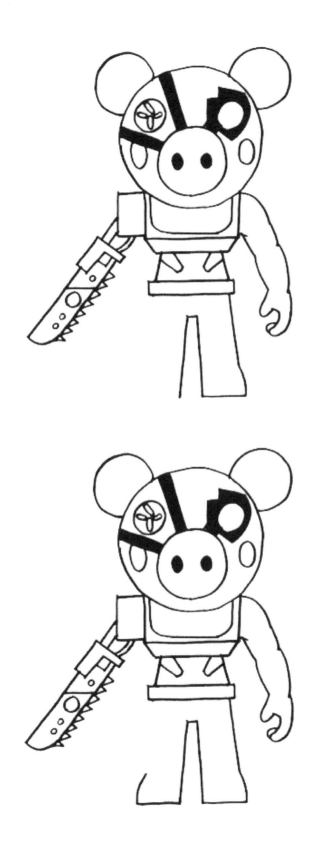

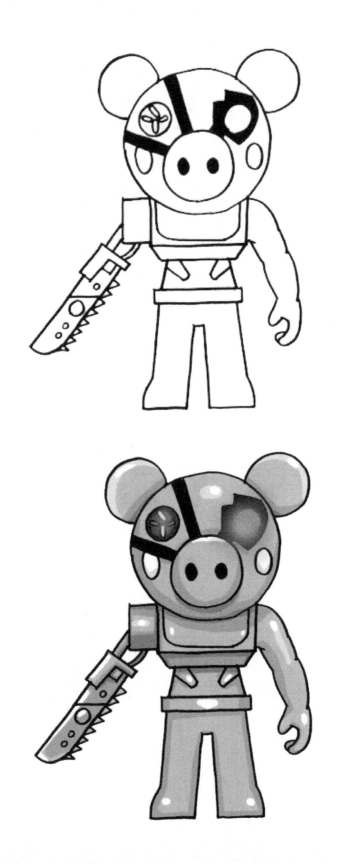

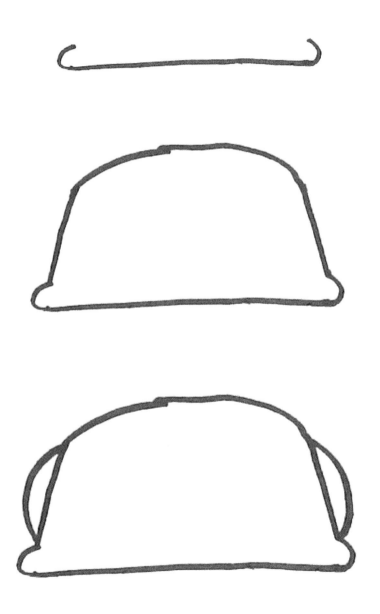

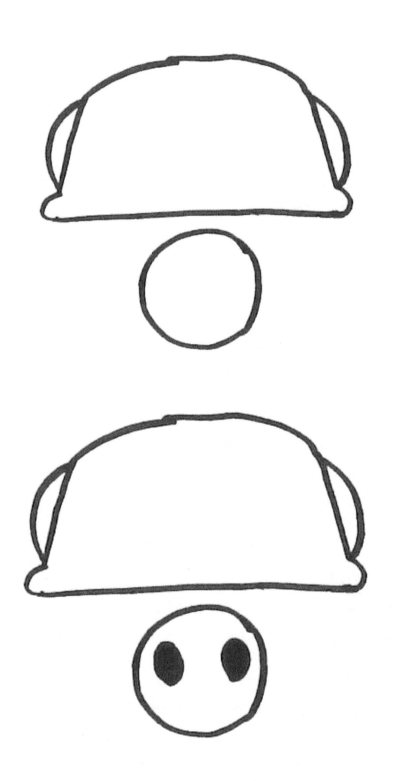

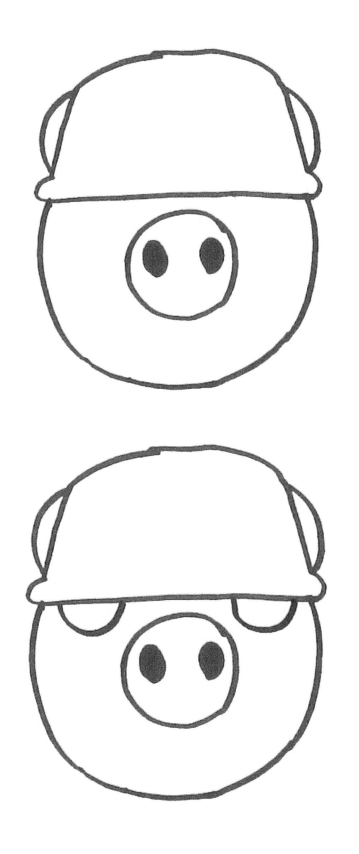

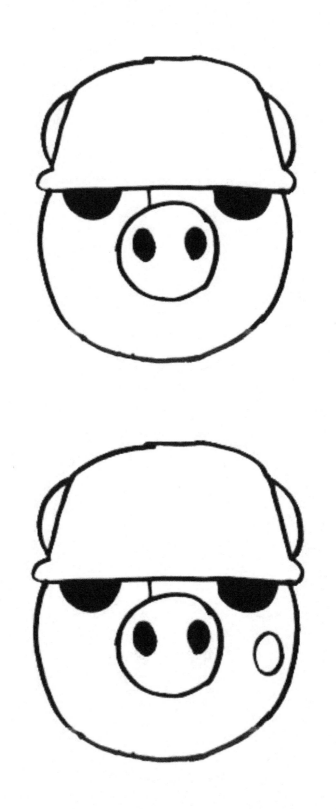

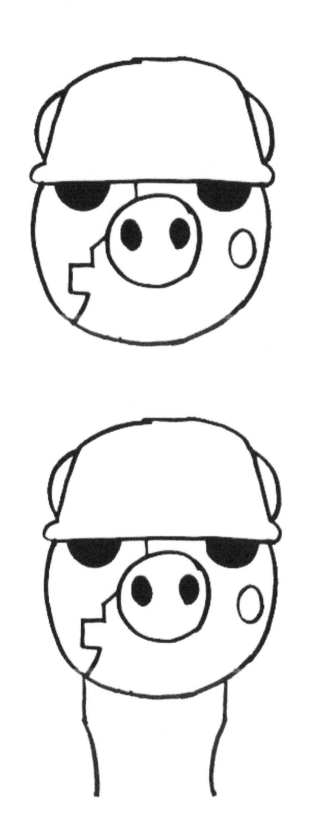

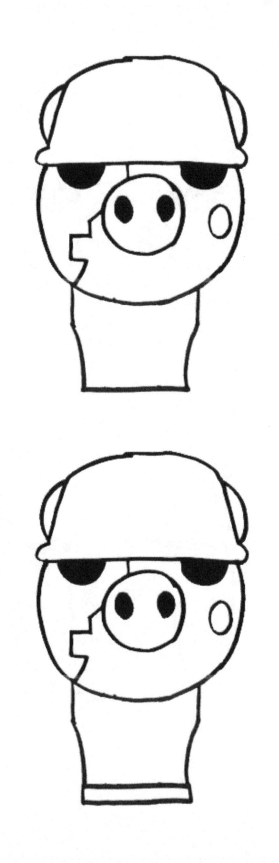

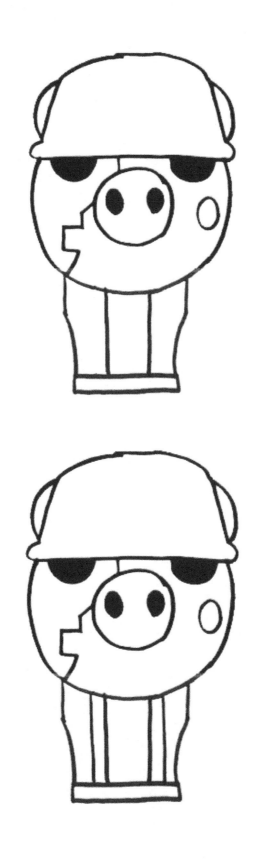

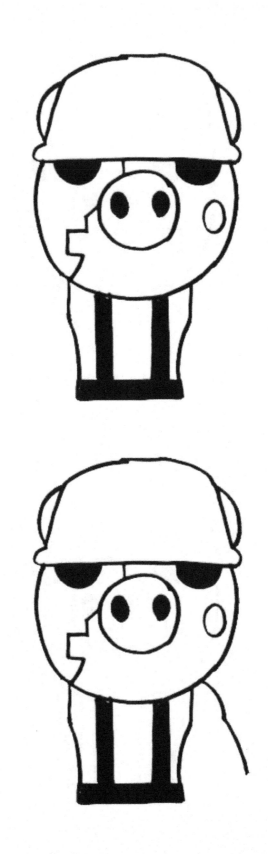

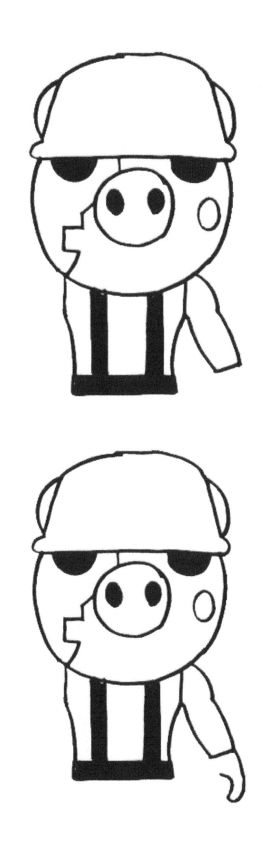

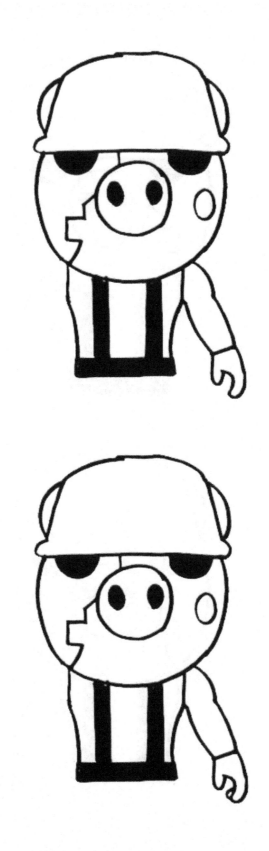

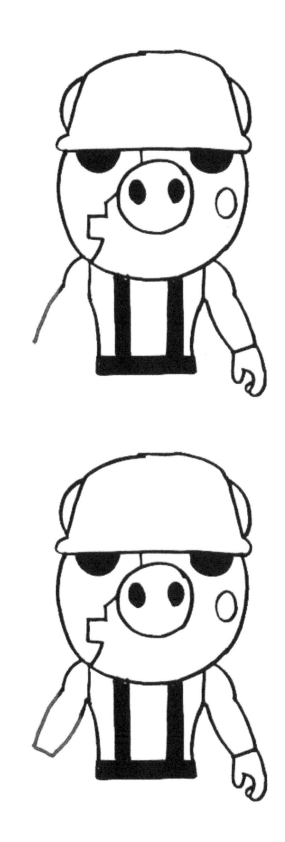

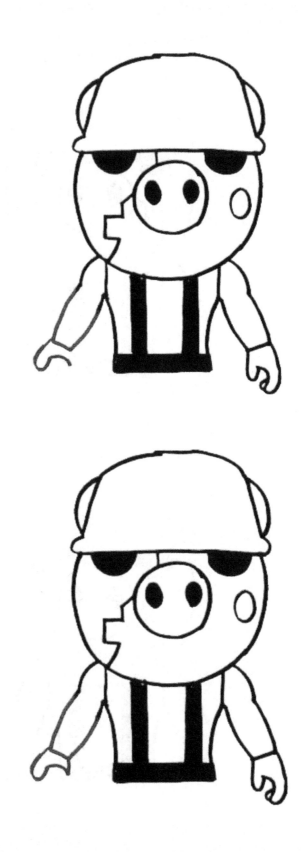

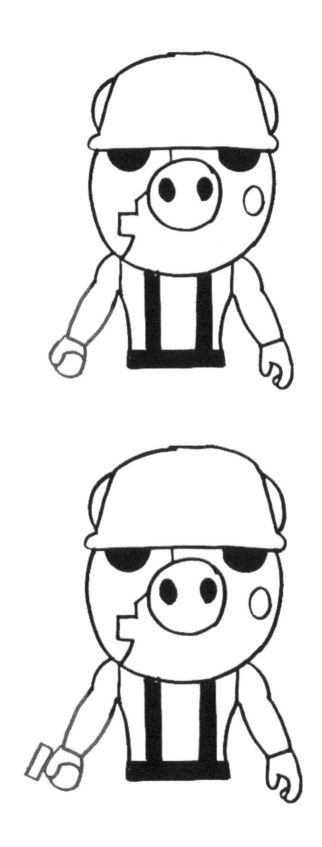

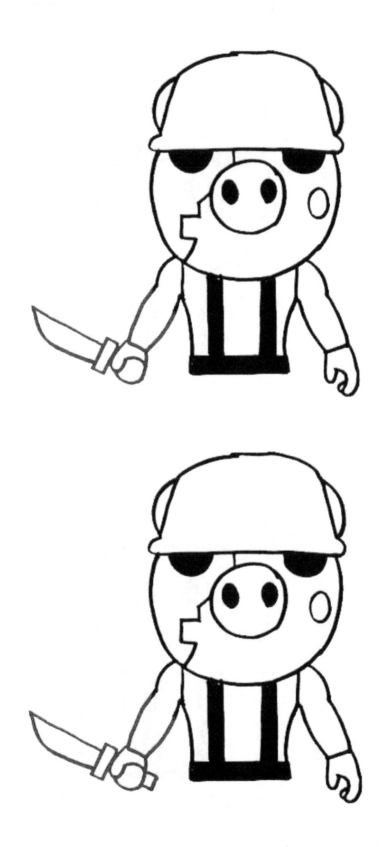

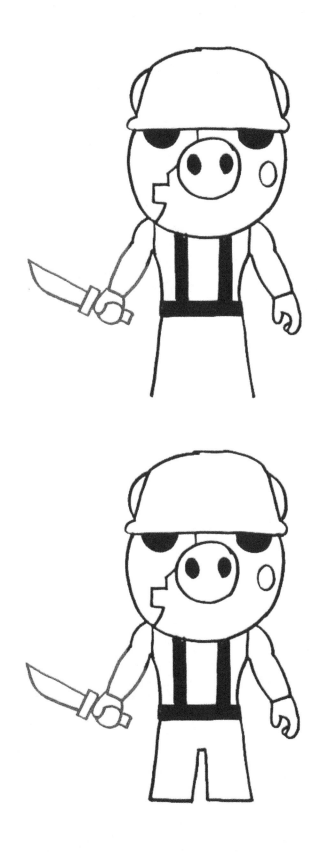

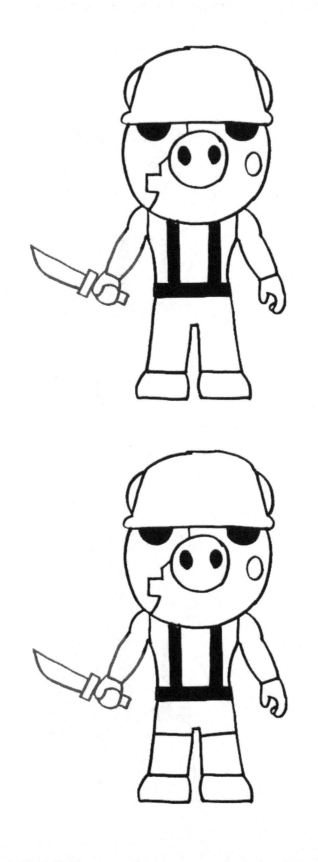

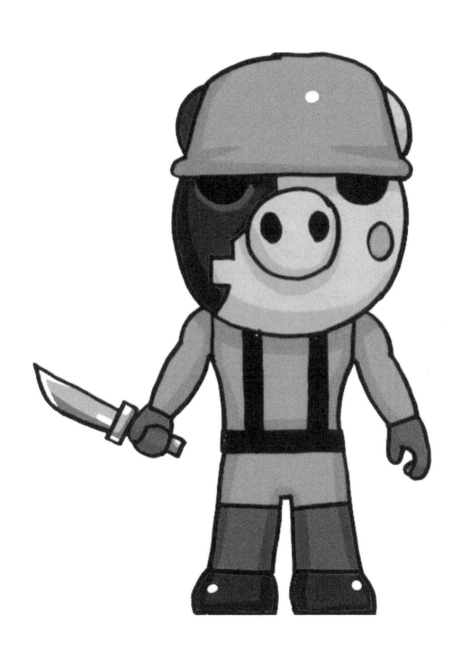

THANK YOU!

I would like to thank you from the bottom of my heart for purchasing my book and reading all the way to the end. I hope that this book both inspires you and gives you the skills you need to start down the path of drawing cute Roblox Piggy Characters. If you found this book interesting and enjoyed reading it, I would really appreciate a short POSITIVE review on Amazon. All of your feedback is valuable to me, as your comments and input will be taken on board to help me make this and future books even better.

Thanks again for your support. I wish you good luck in your drawing journey!

-- Kathy Young --

CHECK OUT OTHER BOOKS

Go here to check out other related books that might interest you:

How To Draw Star Wars Characters: The Ultimate Guide To Drawing 18 Cute Star Wars Characters Step By Step.

https://www.amazon.com/dp/B08HZGPJFW

Drawing Star Wars Characters For Beginners: The Easy Guide For Beginners To Drawing 16 Cute Star Wars Characters In Simple Steps.

https://www.amazon.com/dp/B08HZDGK4M

Learn To Draw Star Wars Characters: The Step By Step Guide To Drawing 15 Amazing Star Wars Characters Easily.

https://www.amazon.com/dp/B08HZ8HGXT

How To Draw One Piece Characters: The Step By Step Guide To Drawing 12 Cute One Piece Characters Easily.

https://www.amazon.com/dp/B08LQ6S6KT

How To Draw Dragon Ball Z: The Easy Guide For Beginners To Drawing 10 Cute Dragon Ball Z Characters In Simple Steps.

https://www.amazon.com/dp/B08LBD4CT7

How To Draw Pokemon Characters: The Step By Step Guide To Drawing 10 Amazing Pokemon Characters Easily (BOOK 1).

https://www.amazon.com/dp/B08JQLF7ZQ

How To Draw Pokemon Characters: The Step By Step Guide To Drawing 10 Amazing Pokemon Characters Easily (Book 2).

https://www.amazon.com/dp/B08JQLFNZR

How To Draw Pokemon Characters: The Step By Step Guide To Drawing 10 Amazing Pokemon Characters Easily (Book 3).

https://www.amazon.com/dp/B08JQQ2VR1

Made in the USA
Las Vegas, NV
11 December 2020